Then & Now
DORCHESTER

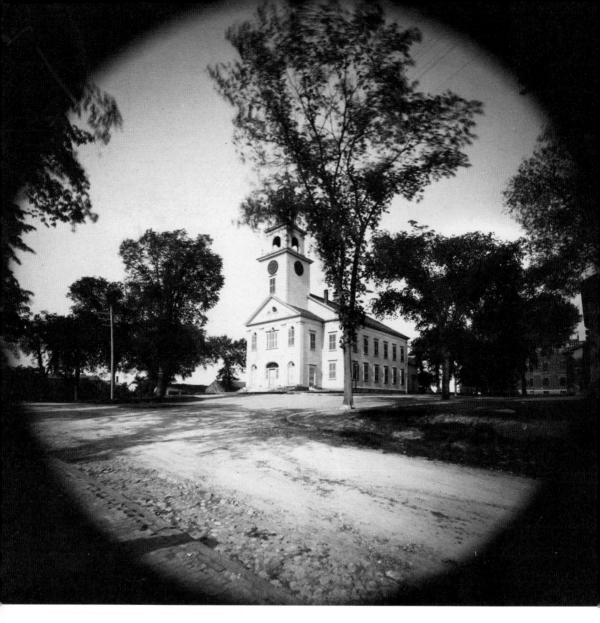

The First Parish Church—gathered in 1630 in Plymouth, England, prior to the Puritans' departure for the New World—is the oldest congregation in the city of Boston. Pictured here in 1885, the Dorchester church was destroyed by fire in 1896. On the right is the Southworth School, which was later replaced by the Mather School. Prominently sited since 1670 on Meeting House Hill, the present church was designed by Cabot, Everett & Mead and was built in 1897. Its lofty spire can be seen from vantage points throughout the area. (Author's collection.)

Then & Now
DORCHESTER

Anthony Mitchell Sammarco

ARCADIA
PUBLISHING

Published by Arcadia Publishing
Charleston SC, Chicago IL, Portsmouth NH, San Francisco CA

Printed in the United States of America

Library of Congress Catalog Card Number: 2004110651

For all general information contact Arcadia Publishing at:
Telephone 843-853-2070
Fax 843-853-0044
E-mail sales@arcadiapublishing.com
For customer service and orders:
Toll-Free 1-888-313-2665

Visit us on the Internet at www.arcadiapublishing.com

In memory of Martin J. Mitchell (1879–1973).

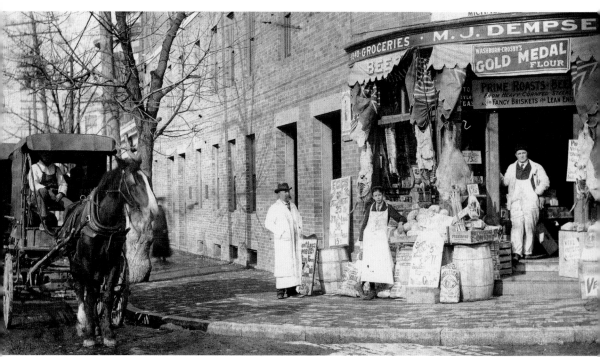

M. J. Dempsey operated a grocery store at the corner of Dorchester Avenue and Templeton Street (now Monsignor Lydon Way), on the first floor of a red-brick apartment house known as the Templeton. Clerks in white coats and aprons stand in front of the establishment, alongside the store's horse-drawn delivery wagon. (Courtesy of Earl Taylor.)

CONTENTS

ACKNOWLEDGMENTS

I would like to thank those who assisted, either directly or indirectly, in the writing of this book: Joan B. Almeida, Robin Alsop, Anthony Bognanno, the residents of the Boston Home Inc., Helen Buchanan, Frank Cheney, Elise Ciregna and Stephen LoPiccolo, Clara May Clapp, the late Elizabeth W. Clapp, the late Mary C. Clapp, Regina Clifton, the Reverend Elizabeth Curtiss, Dexter, the Dorchester Community News, the Dyer family, eBay, John B. Fox, the late Walter S. Fox, Philip Gavin, Stephen Wentworth Gifford, Jean Goldman, Edward W. Gordon, Helen Hannon, Elaine Croce Happnie, the late Elizabeth B. Hough, Paul A. Leo, Phil and Jane Lindsay, John Franklin May, Judith McGillicuddy, Ellen Ochs, Michael Monti Parise, Fran Perkins, Charlie Rosenberg, Anthony and Mary Mitchell Sammarco, Michael Sand, Robert Bayard Severy, Earl Taylor (president of the Dorchester Historical Society), the Urban College of Boston, Peter Van Delft, the Victorian Society (New England Chapter), and Virginia White.

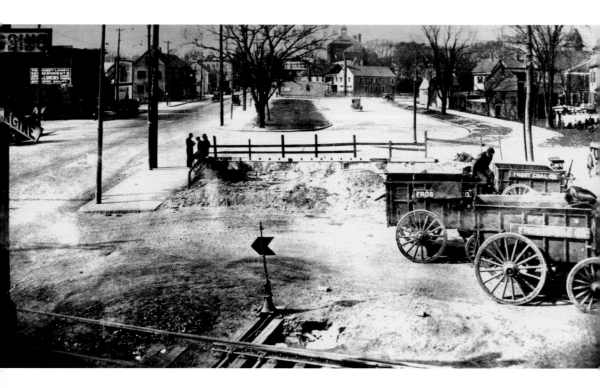

This photograph was taken from the bridge that leads to Quincy from the present Neponset Circle. The northward view along Neponset Avenue shows an area that was both residential and commercial in nature. The tracks in the foreground are those of the Old Colony Railroad, and the delivery wagons on the right belong to the Frost Coal Company, which stood where Sozio Appliances is today. In the center distance is the Minot School, and on the far right are the twin towers of the firehouse on Walnut Street in Port Norfolk. (Author's collection.)

INTRODUCTION

Settled in 1630 by a group of Puritans from the west country of England, Dorchester is among the oldest of the towns of Massachusetts Bay Colony. The vast boundaries of the town once reached from present-day South Boston to within a few hundred feet of the Rhode Island border, and included the present Boston neighborhoods of South Boston and Hyde Park, and the towns of Milton, Canton, Sharon, Stoughton, Foxboro, Wrentham, Raynham, and parts of Dedham and Squantum. As early as 1634, the Neponset River had been harnessed for waterpower, and mills grew up along its banks. Among these were a gristmill erected by Israel Stoughton, a gun-powder mill, a paper mill, and a chocolate mill, all of which lent prominence to the town and made Dorchester an industrial beehive.

For the first two centuries after the settlement of the town, Dorchester saw the setting off of lands for new towns, but the center remained focused on Meeting House Hill, which not only was the religious center of Dorchester but also had been the hub of town government since 1670. The selectmen of Dorchester had established a form of representative government shortly after the town was founded, and thereafter selectmen would oversee town government. The town had an industrial center at the Lower Mills on the Neponset River, and the majority of the land was used for agrarian purposes. However, by the early 19th century, Dorchester began to see development, with the establishment in the 1840s of the Old Colony Railroad, which connected South Shore towns to Boston by a train that had passenger depots in Dorchester. Depots such as Crescent Avenue, Savin Hill, Harrison Square, and Port Norfolk allowed residents to commute to the city for business and pleasure. Within a short time, the Dorchester and Milton Branch of the Old Colony Railroad was laid out in 1856 to Mattapan, with depots at Field's Corner, Shawmut, Ashmont, Milton Village, Central Avenue, and Mattapan. This ease of transportation to and from Boston revolutionized Dorchester as a place of residence. In the period between 1850 and the Civil War, the town's population increased tremendously, with the beginnings of a residential building boom that went unabated for the next seven decades.

By the 1860s, Dorchester's population had doubled from just a few decades before, with many new residents finding the town both attractive as well as convenient. In 1800 there were 2,347 residents, and by 1850 that number had grown to 8,000. Homes were built on the numerous hills that overlooked Dorchester Bay and Boston Harbor, affording residents breathtaking vistas. The Blue Hills in the distance and the open lands to its west gave Dorchester a rural aspect that attracted people from the city who opted to live in the country, albeit a 20-minute train ride away. The networking of horse-drawn streetcars along Dorchester Avenue in 1856— connecting Dorchester Lower Mills to downtown Boston—brought a wave of newcomers who built houses, filled the schools with their children, and clamored for increased services. By the late 1860s, residents had begun to suggest annexing the town to Boston as a ward of the city (as nearby Roxbury had done in 1867), which would provide the advantages of urban services that included public schools, libraries, fire and police departments, as well as necessary amenities such as streets, sewerage system, and water and gas connections. On June 22, 1869, the voters of Dorchester met at town hall (now the site of the Great Hall in Codman Square), where the majority voted to annex the venerable town to the city of Boston. Effective January 4, 1870, the town ceased to exist and Dorchester officially became a ward, or neighborhood, of Boston.

The proponents of the annexation, many of whom had moved to Dorchester in the period 1845–1869, had thus made their dream a reality. As William Dana Orcutt wrote in his 1893 book *Good Old Dorchester*, the "anticipations of the most sanguine annexationists have been more than realized in the growth and development of Boston's oldest and most famous suburb." Within a short period of time, land values increased tremendously. Said Orcutt: "Streets were opened here and there; estates were divided to give increased opportunities for building; and houses sprang up, as if by magic, to meet the demands of the rapidly increasing number of inhabitants. Dorchester, which had been gradually filling up with strangers who were attracted

by the numerous advantages offered by the town, during these years added more names to its already long list of residents who could claim it only as the home of their adoption." The descendants of the old families who owned extensive tracts of land throughout the town, perceived the newcomers as "strangers" who were usurping their town, its history, and their "sacred associations." However, after 1870, all Dorchester residents were considered citizens of Boston, and the tremendous changes wrought over the next few decades affected both new and old residents equally.

By the turn of the 20th century, Dorchester made up one-fifth the area of the entire city of Boston, and the town's population had increased from 12,000 at the time of the annexation to 100,000 residents just three decades later. Dorchester's charming landscape of hills and valleys gave land developers in the late 19th century numerous locations upon which to build residences with panoramic views. With convenience to the Old Colony Railroad and the streetcars that ran along the main streets, the new "streetcar suburb" residents found the neighborhood a delightful place to live. As Orcutt wrote: "In close proximity to the ocean, with refreshing breezes throughout the summer months, superb views from its elevated points of Boston Bay, and harbor of unrivaled beauty, combining the freedom and delights of the country with the advantages and privileges of the city, pure invigorating air, good drainage—all these features are steadily drawing the most desirable class of home builders. Most of its territory is occupied by handsome, attractive private residences, with extensive grounds, beautiful lawns, and shade trees around them; while the stores are clustered around certain centers, such as Upham's Corner, Mt. Bowdoin, Field's Corner, Ashmont, Lower Mills, Mattapan, Neponset, and on Washington Street at the terminus of the Grove Hall and Dorchester branch of the West End [streetcars]."

By the early 20th century, Dorchester's vast population included an eclectic mix of people—from the descendants of the first Colonists to the newest immigrants to the United States. A neighborhood "melting pot," Dorchester has embraced its new residents, who cover a broad spectrum of ethnicity, religion, and race. The development of land for housing in the 20th century has included both architecturally significant houses as well as two-family houses and three-deckers (Dorchester's unique contribution to American architecture). Beginning in the late 1880s, speculators built three-decker residences that allowed three families to live in comfort. By the Great Depression, almost 35 percent of Dorchester's housing stock was composed of three-deckers, the architecture of which ran the gamut from impressive designs to the simplest of buildings.

In the years prior to World War II, Dorchester's population neared a quarter of a million people. The community became famous as the home of such luminaries as politician John "Honey Fitz" Fitzgerald (mayor of Boston and grandfather of Pres. John Fitzgerald Kennedy), actors Leonard Nimoy and Ray Bolger, and disco sensation Donna Summer—representative of Dorchester's Irish, Jewish, and African American populations, respectively. In many ways, the annexation of Dorchester to the city of Boston opened the town for development, and it attracted new residents who contributed to the rich fabric woven by those from diverse backgrounds. Today, Dorchester is a thriving nexus of people who call this venerable town "Home."

As Orcutt wrote in *Good Old Dorchester*: "The Dorchester citizen of to-day may feel that . . . he is far ahead of his ancestor who trod on the same ground more than two centuries and a half ago. Well he may feel so; and yet let him remember that, long years after he has passed away and is forgotten, the history of the first town government and the first free public school will keep alive the memory of those who laid the foundations of Good Old Dorchester." Well, I hope that through *Dorchester Then and Now*, which is my third book on Dorchester, the memory will be kept alive and the community's ever-evolving and rich history will be chronicled for future generations who choose to become Dorchesterites.

In *Dorchester Then and Now*, I have tried to explore a part of the municipal history of Dorchester along with photographs and information about some of its public schools, places of worship, means of transportation, streetscapes, and historic houses. With the able assistance of Charlie Rosenberg, who has taken the "Now" photographs for many of my books, we have tried to select photographs that capture the history of Dorchester, combined with images that show the current state of the same locations. In some instances, hindrances prevented us from taking photographs at the exact location of the older image; nevertheless, we hope this book will lead to a greater appreciation of Dorchester's rich history.

ountain Engine No. 1, seen in 1858, was a volunteer fire company in the Lower Mills. Founded in 1792 as the Dorchester and Milton Fireward Society, it served both Dorchester and Milton. Members of the fire company, some wearing their official hats of office, pose around the hand-pump engine in front of Talbot's, a grocery store on Washington Street near River Street. (Courtesy of the Milton Historical Society.)

Chapter 1

THE TOWN OF DORCHESTER

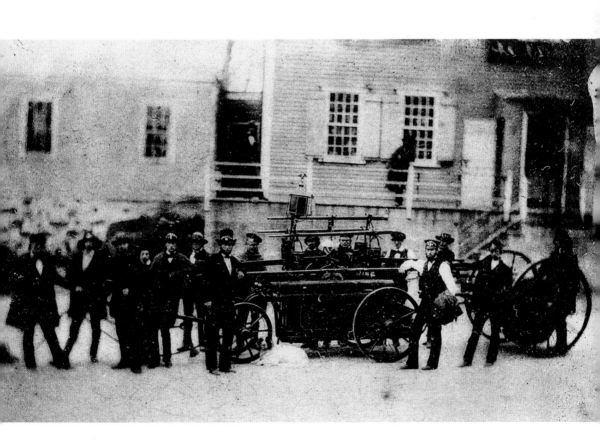

The Dorchester Town Hall was built in 1816 in Baker's Corner, which since 1849 has been known as Codman Square in memory of the Reverend John Codman, minister of the Second Church in Dorchester. Seen in a view looking up Norfolk Street, the red-brick one-story town hall served as Dorchester's political center until January 4, 1870, when the town was annexed to the city of Boston. Today, this is the site of the Great Hall, the former Codman Square Library, built in 1904 and designed by city architect Charles Bateman. (Author's collection.)

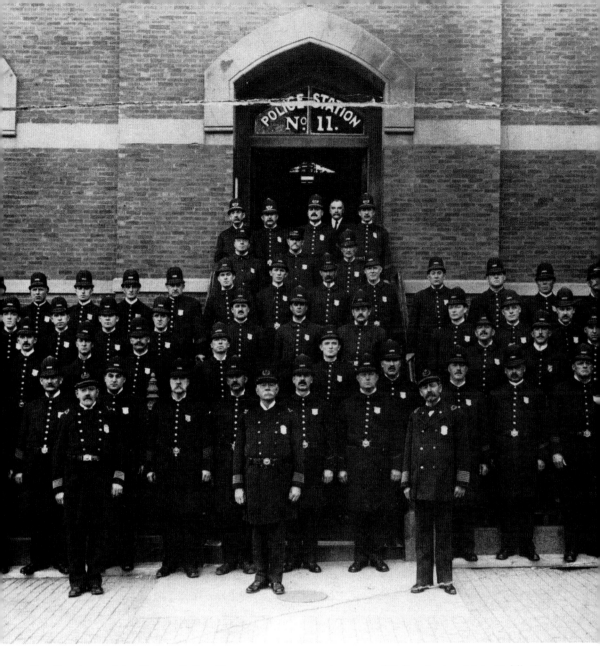

Members of the Boston Police Department pose on the steps of Police Station 11 in Field's Corner in 1911. Now known as One Arcadia Place, the building at the corner of Adams and Arcadia Streets was designed by Boston city architect George A. Clough and was constructed in 1874. The structure served as the municipal courthouse, police station, and branch library for many years, until 1925, when the present Dorchester Municipal Courthouse was built in Codman Square. Today, One Arcadia Place is an important part of the ever-evolving Field's Corner streetscape.

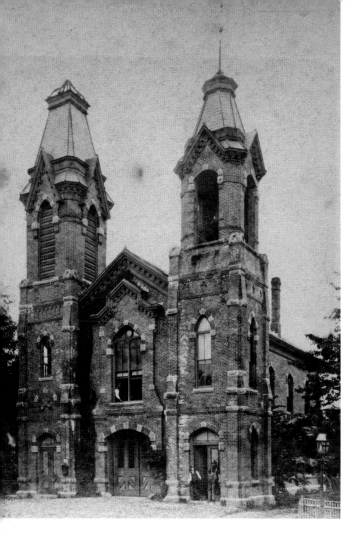

The two-towered engine house on Babcock Street in Mattapan was built in 1882 and designed by the city architect of Boston, Charles Bateman. The red-brick, Ruskinian Gothic firehouse served the needs of the new ward of the city. Today, the site is occupied by the Mattapan Early Education Center. (Author's collection.)

The Port Norfolk Firehouse was at the corner of Walnut Avenue and William T. Morrissey Boulevard. Today, the site is a small tree-shaded park named in memory of William Fitzgerald (1952–1974). (Courtesy of Earl Taylor.)

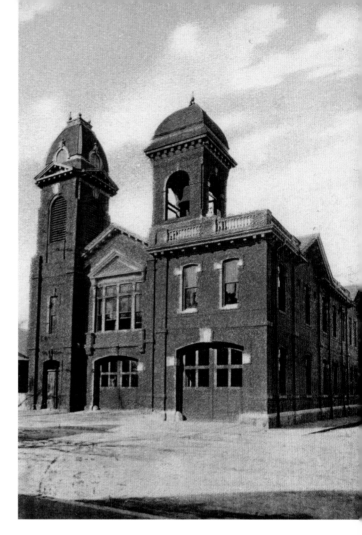

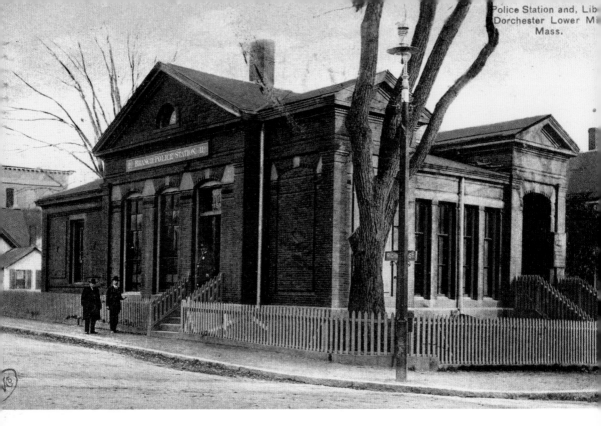

The Blue Hill Bank was chartered in 1832, and this red-brick and brownstone building, designed by Nathaniel J. Bradlee, was erected in 1871. Later used as a police station and as a branch of the Boston Public Library, the panel-brick one-story building is at the corner of Washington and Richmond Streets. On the far left is a corner of the Gilbert Stuart School, now the site of the present Lower Mills Library. Today, the bank building is a private residence at 1110 Washington Street. (Courtesy of Earl Taylor.)

The Dorchester Municipal Building is at the corner of Columbia Road and Bird Street, just west of Upham's Corner. Designed by Charles Besarick, the four-story Classical Revival building has quoining, Ionic pilasters, and huge arched windows that carry one's eye up the facade of the building. The entrance is a rusticated arch of limestone with Ionic columns supporting a tin balustrade. Today, the building houses the local library and a health center. (Author's collection.)

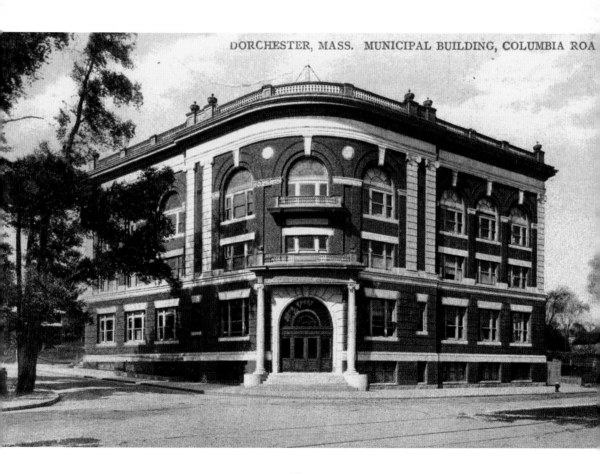

DORCHESTER, MASS. MUNICIPAL BUILDING, COLUMBIA ROA

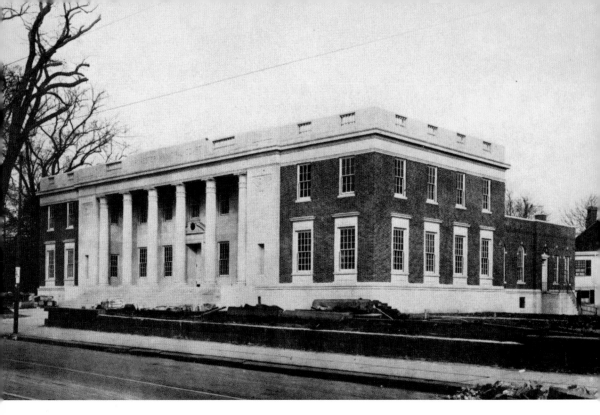

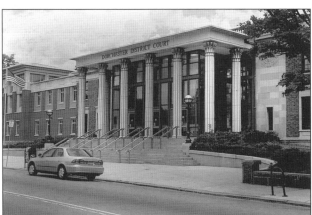

The Dorchester Municipal Courthouse, designed by the Boston architectural firm of Holmes & Edwards, was built in 1925. There were originally three houses on this block between Tremlett Street and Melville Avenue; the center house was a large Italianate mansion later used as Resthaven, a private hospital. The courthouse has a Classical Revival facade of red brick and limestone. In 1997, the building was greatly enlarged, with a distinctive entrance of lotus-inspired columns supporting an unornamented cornice and flanking symmetrical wings of red and buff brick. (Author's collection.)

The Tileston School, on Norfolk Street in Mattapan, was built in 1868 to serve the children of the Mattapan area. The school was named for Edmund Pitt Tileston, who in 1801 cofounded the Tileston & Hollingsworth Paper Company with Mark Hollingsworth. Tileston donated a library and tower clock to the school. (Author's collection.)

Chapter 2

DORCHESTER SCHOOLS

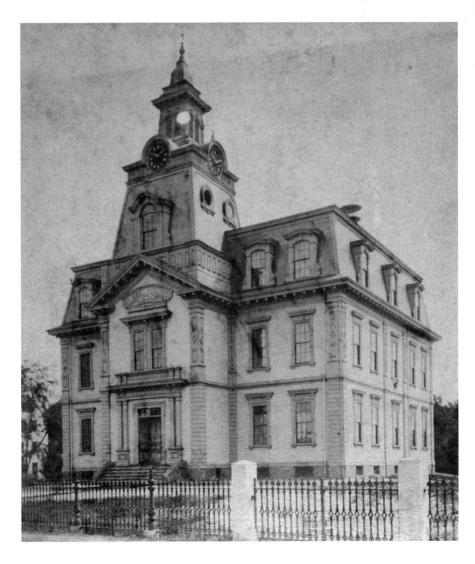

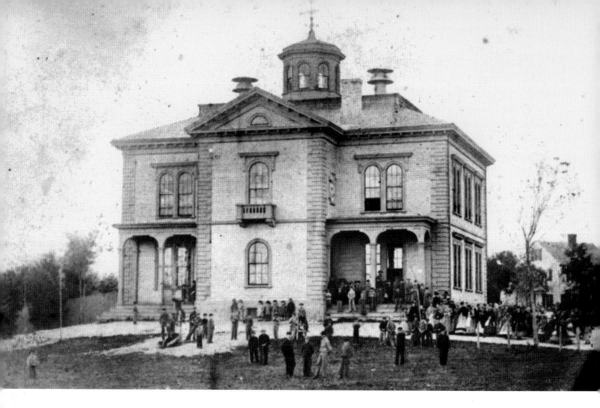

The Gibson School was on School Street, opposite Mother's Rest. The school was designed by noted architect Gridley J. Fox Bryant, and was endowed by Edmund Tileston and Roswell Gleason. The Italianate schoolhouse was named for Christopher Gibson, an early settler who left land to support the schools in Dorchester. Gibson's gift is also perpetuated by Gibson Field, located at the corner of Park Street and Dorchester Avenue in Field's Corner. (Author's collection.)

The second Gibson School was on Columbia Road, just east of Geneva Avenue. The school had been built as the Atherton School (named in honor of Maj. Humphrey Atherton) but was renamed for Christopher Gibson. Today, the brick-and-granite-capped wall and stairs survive, along with a chain-link fence encircling a weed-strewn vacant lot. (Courtesy of Earl Taylor.)

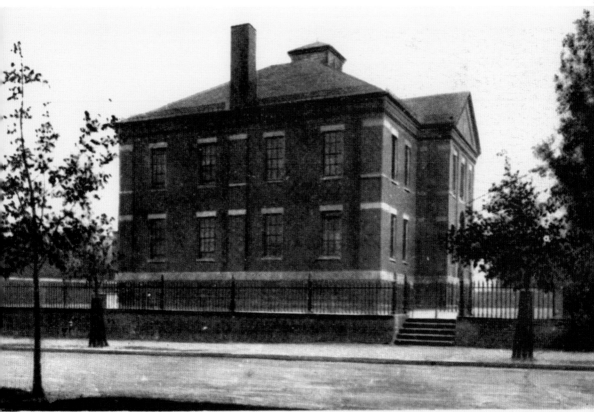

Old Gibson School, Columbia Road, Dorchester, Mass.

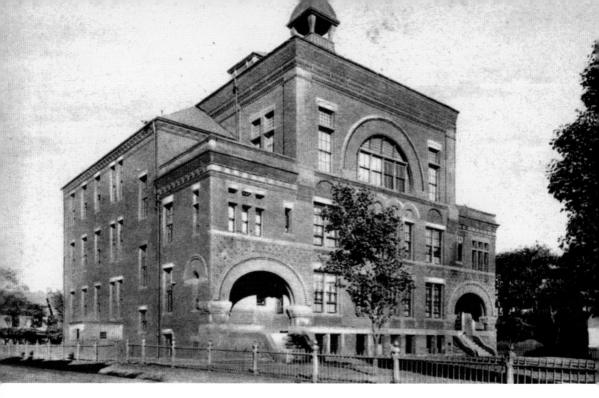

The Minot School was on Neponset Avenue, opposite Minot Street. Built in 1886, it was named for George Minot, an early settler of Dorchester and once ruling elder, who died in 1671. His house stood opposite the school until 1874, when the home was destroyed by fire. Today, the former school site is occupied by the Neponset Health Center, at 398 Neponset Avenue. (Courtesy of Earl Taylor.)

The Robinson School, designed by James Mulcahey, was on Robinson Street, off Adams Street, near Field's Corner. The school was named for John H. Robinson (1809–1883), whose house (built in 1788) stood at the corner of Adams and Robinson Streets, today the site of the Telephone Building. The former location of the Robinson School is now a vacant lot, but the rough-hammered granite wall and piers survive, along with portions of the iron fencing. (Courtesy of Earl Taylor.)

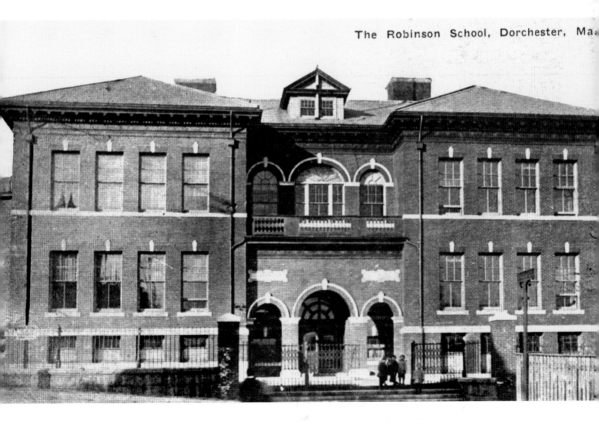

The Robinson School, Dorchester, Ma.

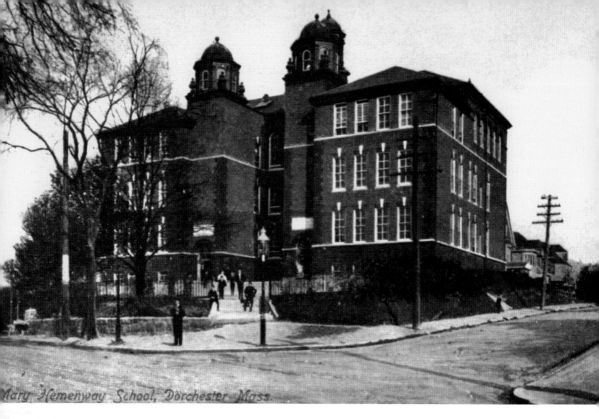

Mary Hemenway School, Dorchester, Mass.

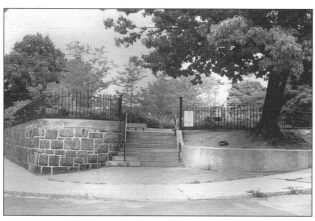

The Mary Hemenway School was at the corner of Adams and King Streets, just south of King Square. The school was named for Mary Porter Tileston Hemenway, widow of Boston merchant Augustus Hemenway. A member of the Boston School Committee, Mr. Hemenway was the person who introduced and personally financed the aspect of domestic science in Boston schools. Today, the site is used as a park, accessible by the stairs that once led to the school. (Courtesy of Earl Taylor.)

The Gilbert Stuart School was designed by Edmund March Wheelwright, and was located on Richmond Street, between Dorchester Avenue and Washington Street. Named for the great early-19th-century portrait painter, the school was demolished in the early 1970s. The site is now occupied by the Lower Mills Branch of the Boston Public Library. (Author's collection.)

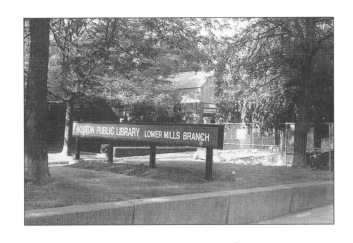

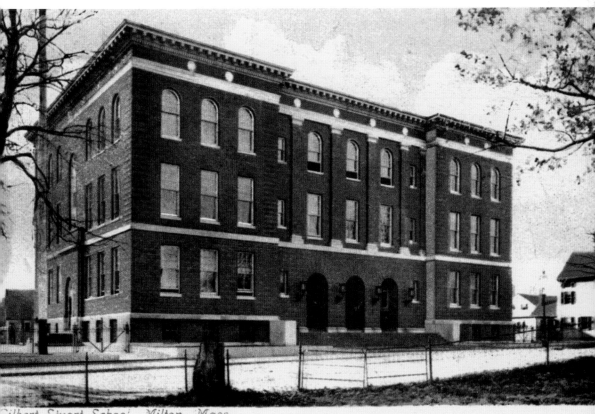

Gilbert Stuart School, Milton, Mass.

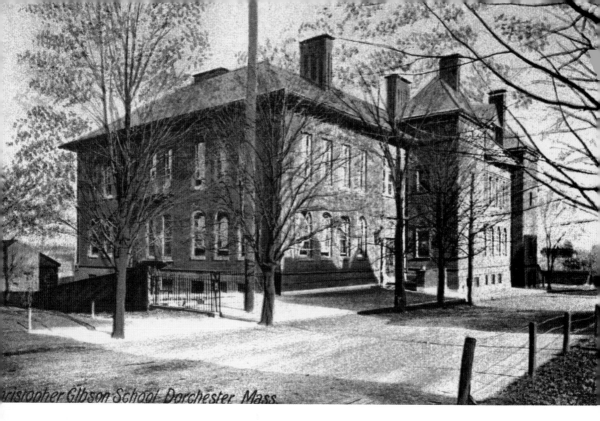

Christopher Gibson School, Dorchester, Mass.

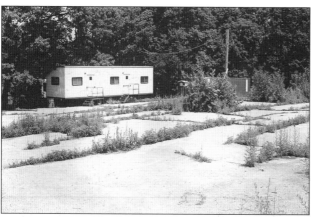

The third edifice of the Christopher Gibson School was designed by city architect Edmund March Wheelwright and was built on Ronald Street. Today, the site is a weed-strewn lot, and a portable office sits at one end of the former schoolyard. (Author's collection.)

The Henry L. Pierce School was designed by city architect and Dorchester resident Harrison H. Atwood (1863–1954). The school, built in 1892 at the corner of Washington Street and Welles Avenue, was named for Henry Lillie Pierce (1825–1896), who owned the Baker Chocolate Company in the Dorchester Lower Mills. Pierce also served as the mayor of Boston in 1872 and 1877 and was a member of the U.S. Congress. Today, the site is the Codman Square Branch of the Boston Public Library. (Courtesy of Earl Taylor.)

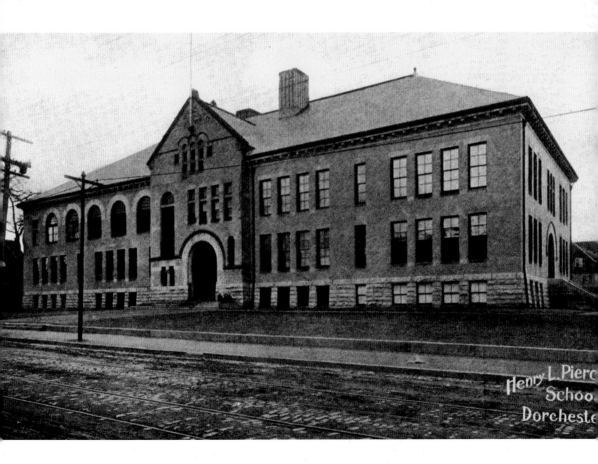

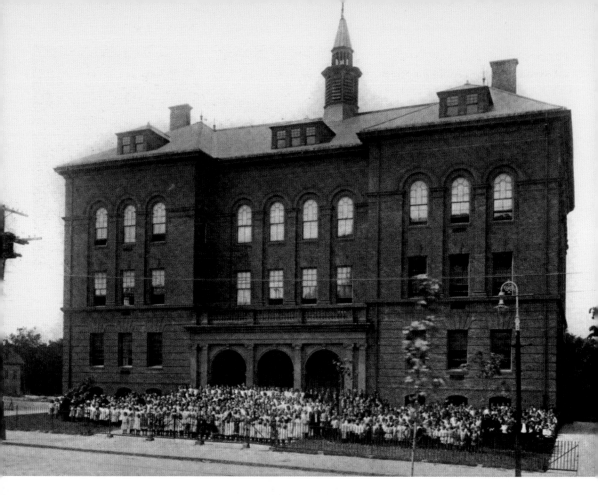

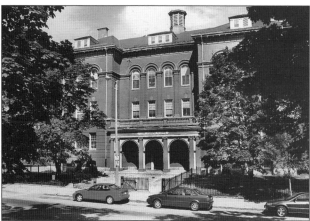

St. Peter's School was designed by William McGinty and was built at 280 Bowdoin Street, near the corner of Quincy Street. St. Peter's Roman Catholic Church was the second Roman Catholic parish in Dorchester, and the church building was constructed in 1872. The parochial school became a well-attended school throughout the 20th century. Today, it is the Harbor School. (Author's collection.)

St. Ann's School is on Neponset Avenue, between Ashmont Street and Boutwell Avenue. On the left is the Silas S. Putnam House. Putnam owned the Putnam Nail Company (in Neponset), which produced both hot- and cold-forged nails for the shoeing of horses. The school remains virtually unchanged, but the site where the Putnam House once stood is now a small lawn between the church and school. (Courtesy of Earl Taylor.)

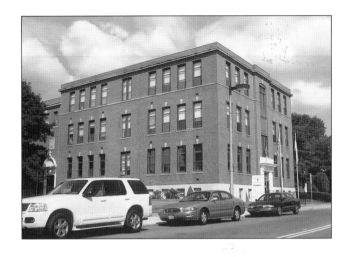

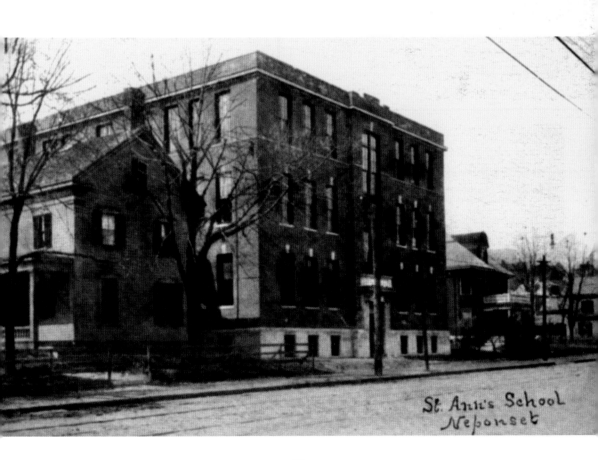

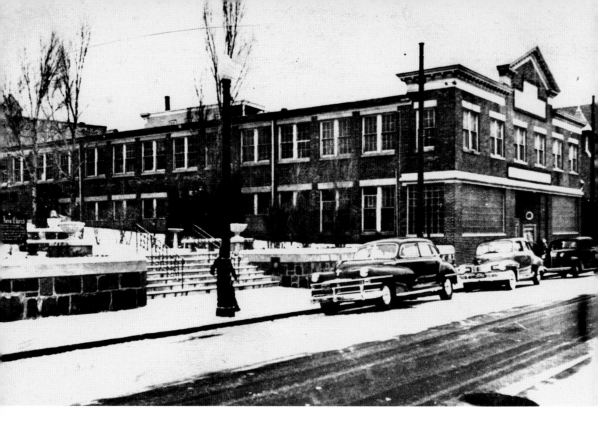

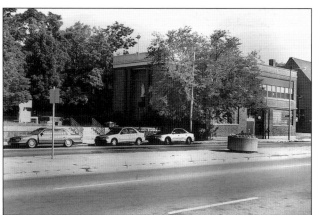

St. Kevin's School is on Columbia Road, at the corner of Arion Street. A former garage and auto parts store, the building was remodeled by the Boston architectural firm of Holmes & Edwards in 1954. The school is adjacent to St. Kevin's Roman Catholic Church. Seen on the far right is a corner of Pilgrim Congregational Church, designed by Stephen A. Earl and built in 1893. (Author's collection.)

Dorchester's First Parish Church was established by the Puritans who settled Dorchester. The church had been founded in Plymouth, England, in 1630, before the Puritans came to America. First Parish Church is the oldest congregation in the city of Boston, and the building is prominently sited on Meeting House Hill. On the right is Lyceum Hall, a Greek Revival structure built in 1839 and demolished in 1955. On the left is the Southworth School, now the site of the Mather School. In the foreground is the Dorchester Common. The obelisk in front of the church was erected in 1867 by the Pickwick Club to honor the Dorchester men lost in the Civil War. (Courtesy of John F. May.)

Chapter 3

PLACES OF WORSHIP

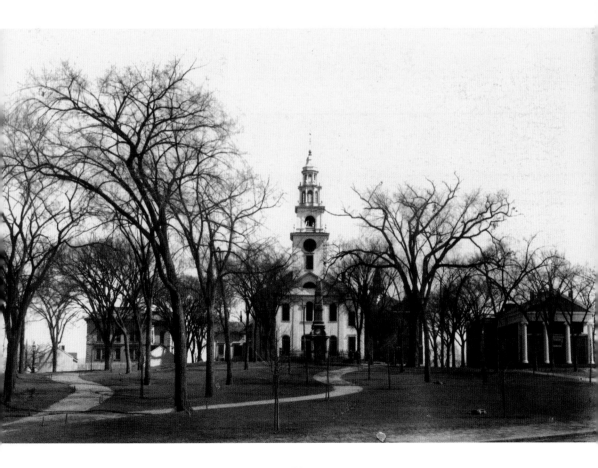

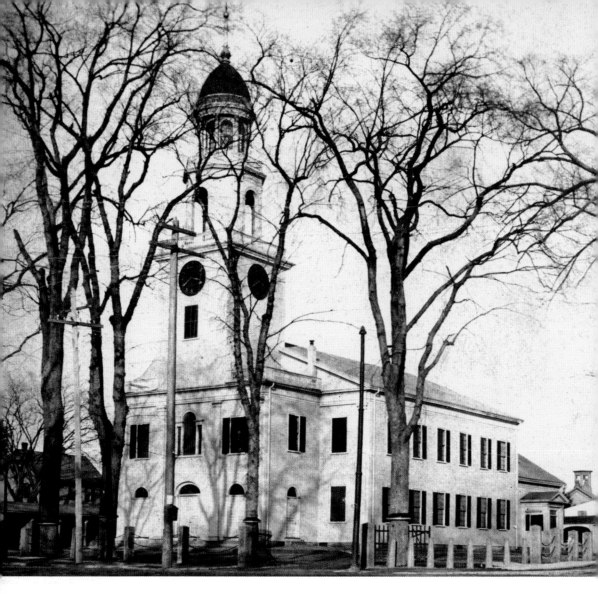

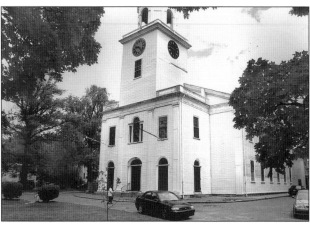

The Second Church in Dorchester is at the corner of Washington and Centre Streets in Codman Square. The church, built by Oliver Warren in 1806 to alleviate the overcrowding at the First Parish on Meeting House Hill, has a bell cast by Paul Revere in its belfry. Second Church was to be presided over by the Reverend John Codman (for whom the square was named in 1849), a beloved minister and friend. Today, the Wesleyan Church worships here. (Author's collection.)

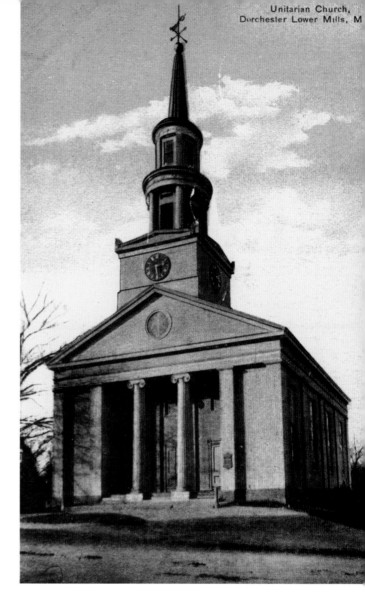

The Third Religious Society in Dorchester, organized in 1813, was built in 1840 on Richmond Street between Washington Street and Dorchester Avenue. Designed by noted architect Asher Benjamin, this impressive Greek Revival church replaced an earlier structure, which was moved to 1111–1113 Washington Street and converted to Richmond Hall (now a multiple-family house). The church was demolished in 1954, when a supermarket was built on the site. Today, Tedeschi's Food Shop and Brooks Pharmacy occupy the property. (Courtesy of Earl Taylor.)

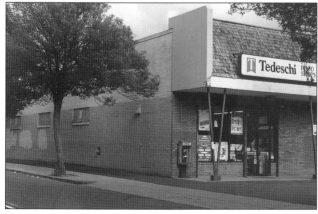

The First Methodist Episcopal Church was founded in 1818, and this church was built in 1874 on Washington Street, just north of Richmond Street. On the left is an 1840s Greek Revival duplex that was indicative of the workers' housing throughout the Lower Mills in the 19th century. On the site today is the decidedly modernistic Wesley United Methodist Church, which was built after a fire destroyed the original church. (Author's collection.)

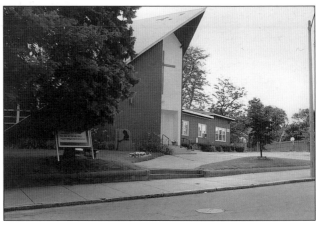

The Baker Memorial Church was founded in 1876 at the corner of Columbia Road and Cushing Avenue. The edifice was built through a legacy left by Sarah Baker, an invalid who made bandboxes. It was demolished in 1944, and the site is now a parking lot for the Fleet Bank (on the right), originally the Dorchester Trust Company. (Author's collection.)

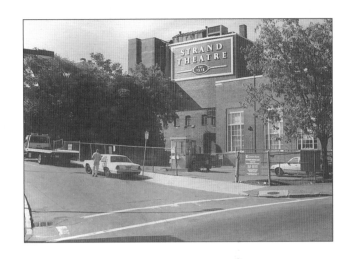

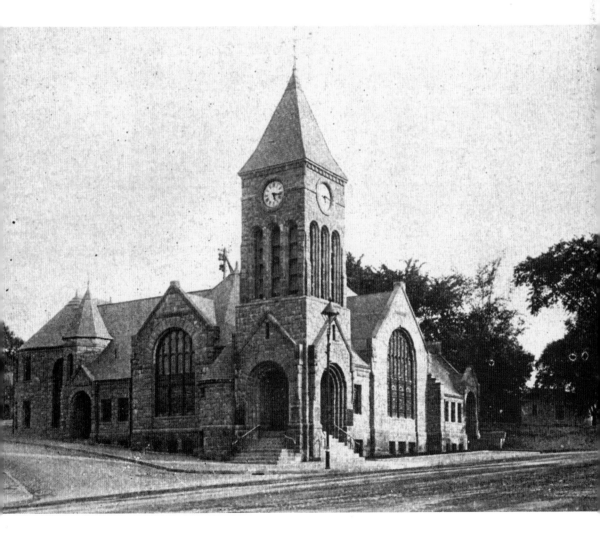

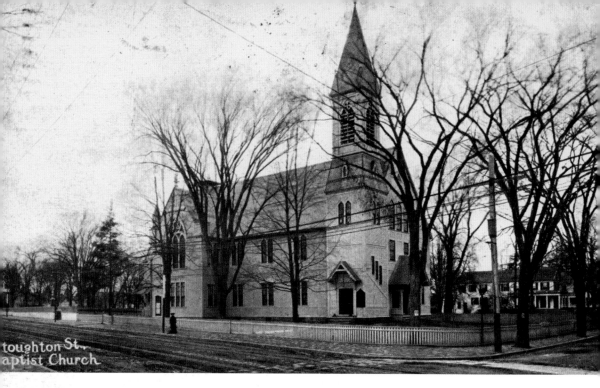

toughton St.
aptist Church

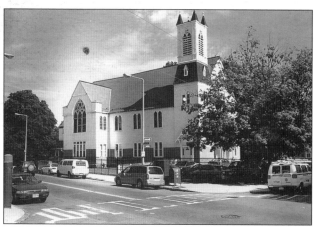

The Stoughton Street Baptist Church, founded in 1845, is on Stoughton Street between the Old North Burying Ground (on the left), and Sumner Street. It is a Stick-style church with a tall belfry. Today, this is the Iglesia Adventista del Septimo Dia, Seventh-day Adventist Church. (Courtesy of Earl Taylor.)

The Blaney Baptist Church, organized in 1882, was on Richmond Street at the corner of Dorchester Avenue. Today, the site is used as the Meetinghouse Bank and a large parking lot. (Courtesy of Earl Taylor.)

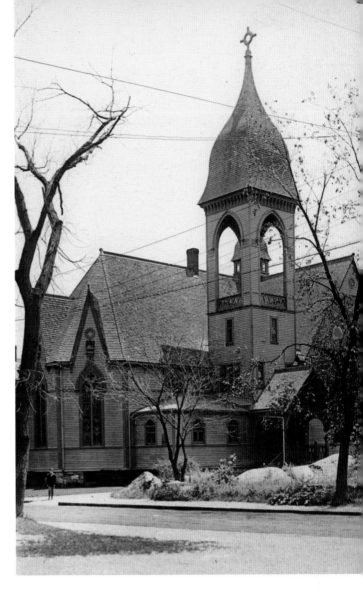

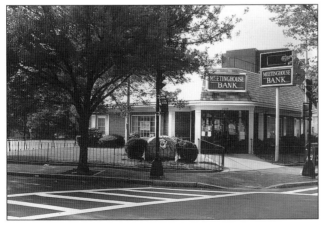

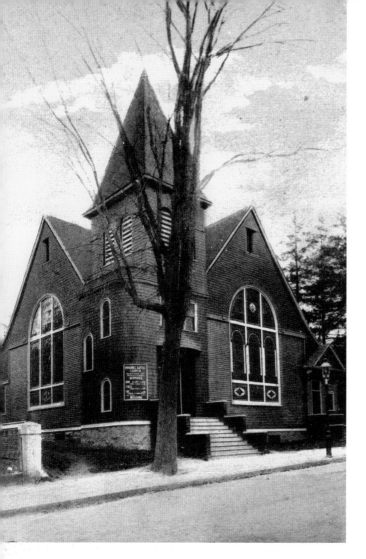

The Immanuel Baptist Church, organized in 1897, was at 191 Adams Street in Field's Corner, adjacent to One Arcadia Place. The site of the church is now a parking lot, which has attractive ironwork along the sidewalk, and a granite embankment wall. (Author's collection.)

Dorchester Temple Baptist Church, organized in 1886, is at the corner of Washington Street and Welles Avenue. The building was designed by Arthur H. Vinal and was constructed in 1889. An impressive Shingle-style church with a large asymmetrical tower, it is a prominent part of the Codman Square streetscape. (Courtesy of Earl Taylor.)

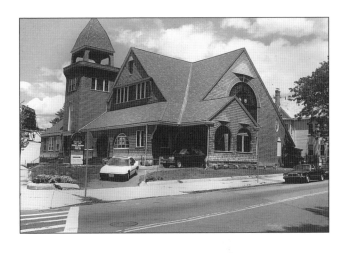

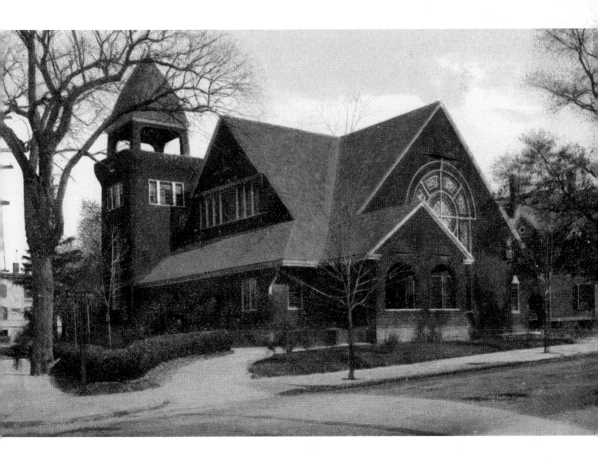

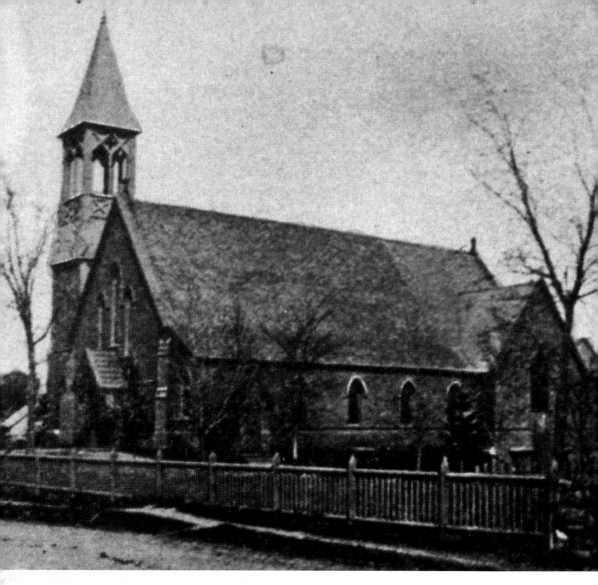

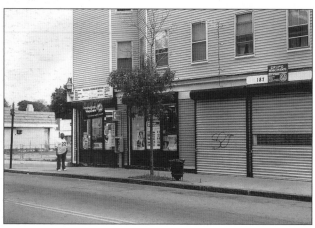

Old St. Mary's Episcopal Church, designed by Arthur J. Gilman, was built in 1861 at the corner of Bowdoin and Topliff Streets. Founded in 1847, it became a large parish that eventually built another church on Cushing Avenue on Jones Hill after an 1887 fire destroyed the church. Today, a three-decker with storefronts on the first floor is located on the site. (Author's collection.)

St. Mary's Episcopal Church is located in Upham's Corner on Cushing Avenue (named for Dr. Benjamin Cushing, a beloved local physician). Designed by Henry Vaughan, it was built in 1888 after a fire destroyed the original church on Bowdoin Street, which is pictured below. The chancel of the new church was designed by Hartwell & Richardson and was built in 1893. The parish house, designed by Charles K. Cummings, was constructed in 1907. Today, St. Mary's is a thriving church. (Courtesy of Earl Taylor.)

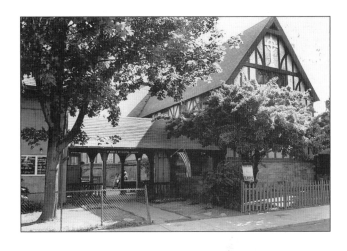

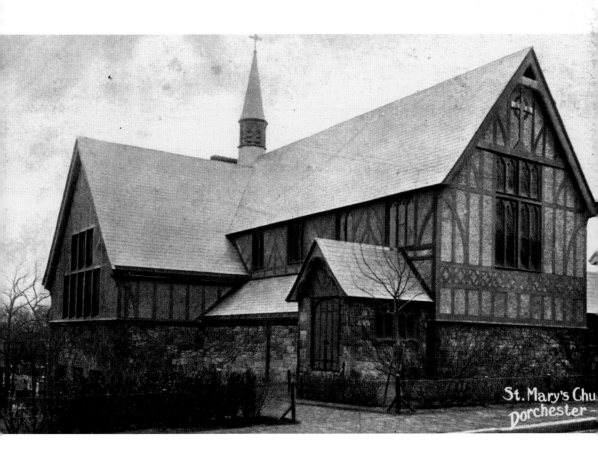

St. Mary's Chu
Dorchester

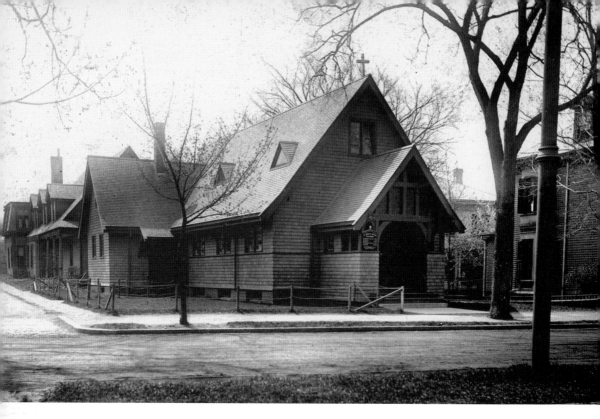

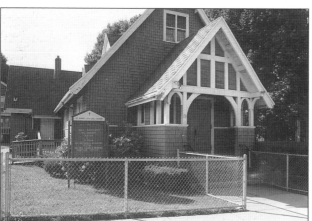

St. Mark's Episcopal Church, founded in 1898 as a mission church, is on Columbia Road at the corner of Seaver Street. The small, one-story craftsman-style church, which was designed by Edmund Q. Sylvester, has an interesting entrance porch that creates an almost English country parish feeling. In 1906, St. Mark's became an Episcopal parish. (Courtesy of Earl Taylor.)

The Church of the Holy Spirit is at the corner of River Street and Cummins Highway. Designed by the noted architect Arthur Rotch (of Rotch & Tilden), it was built through the generosity of Annie Lawrence Rotch Lamb (Arthur's sister) in memory of their father, Benjamin Smith Rotch. With a random-stone base and Tudor Revival strapwork, the huge center tower creates an important and bold aspect to the Victorian church. (Author's collection.)

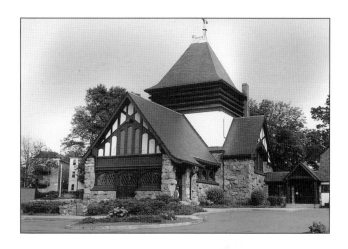

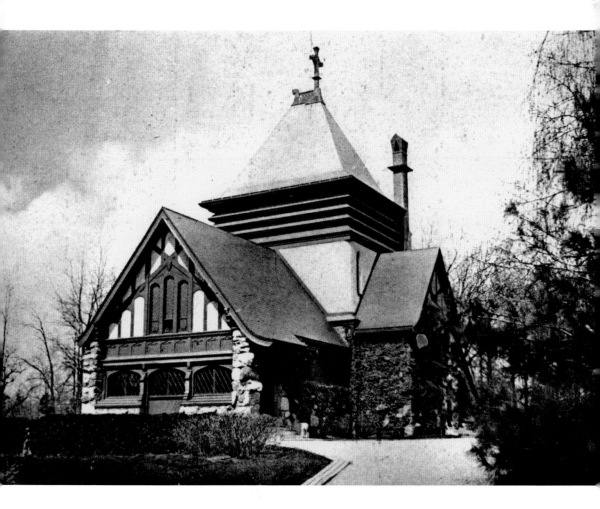

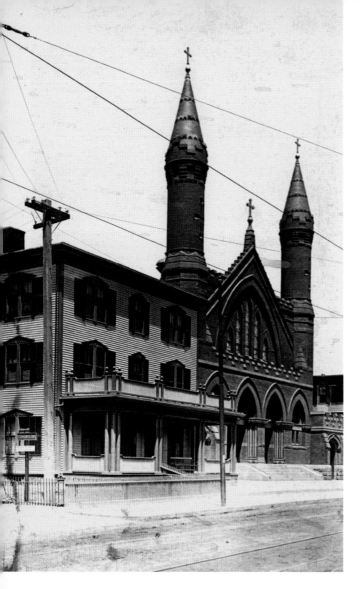

St. Gregory's Roman Catholic Church is at 2215 Dorchester Avenue, between Mother Julia Road and St. Gregory Street. Designed by Patrick C. Keeley and built in 1863, it is the oldest Catholic church in Dorchester. The structure has a crenelated red-brick facade and is distinctive for its twin minaret towers, which were added in 1895 during a remodeling by Patrick W. Ford. The former rectory, built in 1890, is on the left. It was demolished in 1955 after a new rectory was built on the opposite corner. The site was graded for a garden and a beautiful crucifix shrine. (Courtesy of Earl Taylor.)

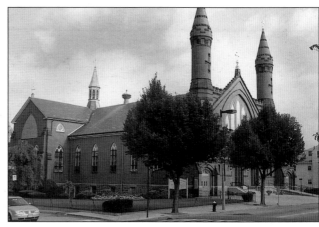

St. Peter's Roman Catholic Church is at the corner of Bowdoin and Percival Streets on Meeting House Hill, opposite Eaton Square. The church was constructed in 1872 from Roxbury pudding stone that was quarried on site. The impressive edifice was designed in the Norman Gothic style by Patrick C. Keeley, the foremost Catholic architect in the 19th century and architect of the Cathedral of the Holy Cross in Boston. The tower of St. Peter's was deemed unsafe in the early 1970s, and the top portion was removed. (Author's collection.)

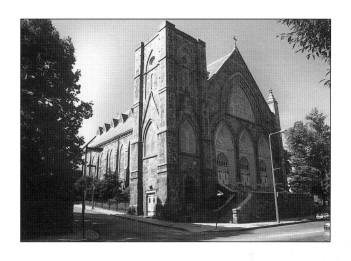

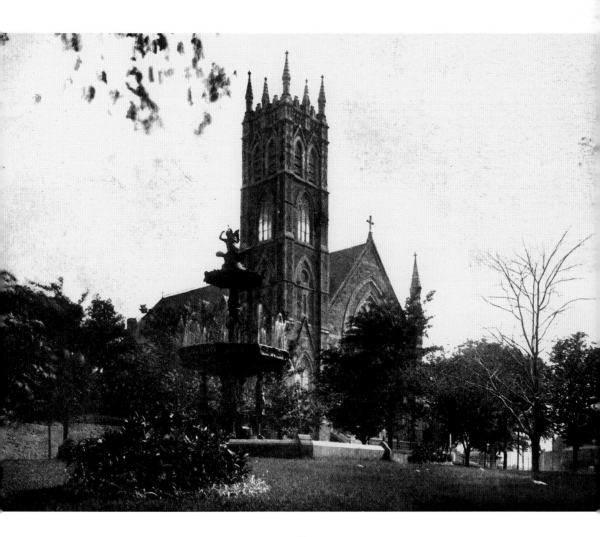

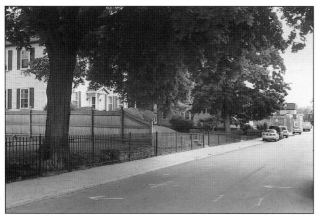

St. Ann's Roman Catholic Church was founded in 1889 and was originally on Minot Street near Neponset Avenue. On the left is the church's Italianate rectory, now used as a multiple-family house. Minot Street was greatly built up with houses in the early 20th century, and today the site of the church is occupied by Rent-All of Boston. (Courtesy of Earl Taylor.)

The present St. Ann's Roman Catholic Church is at the corner of Neponset Avenue and Ashmont Street. When it was built in 1920, the large tapestry-brick church, designed by Edward T. P. Graham, featured four monumental Tuscan Doric columns and a soaring campanile. The facade has since been remodeled. The columns and pediment have been removed, and new stairs and a porch have been added. (Author's collection.)

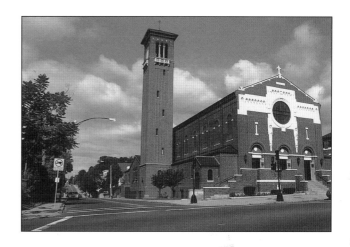

St. Leo's Church and Rectory, Dorchester, Mass.

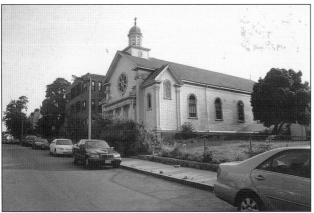

St. Leo's Roman Catholic Church is at 90 Esmond Street, near Harvard Street. The parish was established in 1902, and the Colonial Revival church was built in an area that had experienced development in the 1885–1900 period. On the right is the Thomas Bicknell House, built *c.* 1850. The house was later used as the parish hall, before it was demolished in the late 1950s. Today, St. Leo's has been closed by the Archdiocese of Boston, and the former church remains vacant. (Courtesy of Earl Taylor.)

St. Mark's Roman Catholic Church was founded in 1905, and its church was built in 1915 at 1725 Dorchester Avenue, between St. Mark's Road and Chevrus Road. Brigham, Coveney & Brisbee designed the red-brick church, whose facade has a recessed archway that is flanked by broad, flat piers. (Courtesy of Earl Taylor.)

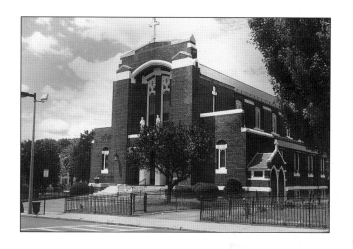

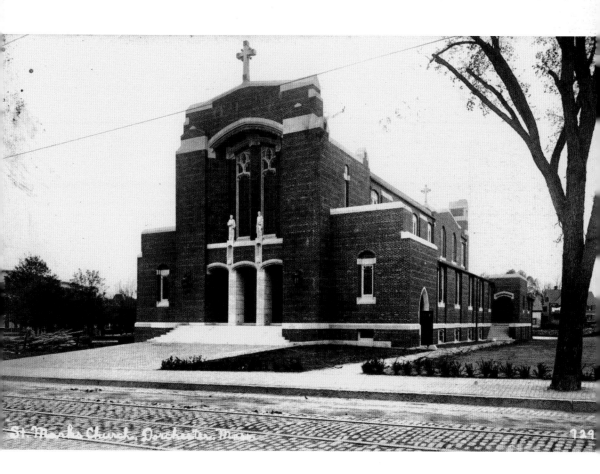

St. Marks Church, Dorchester, Mass

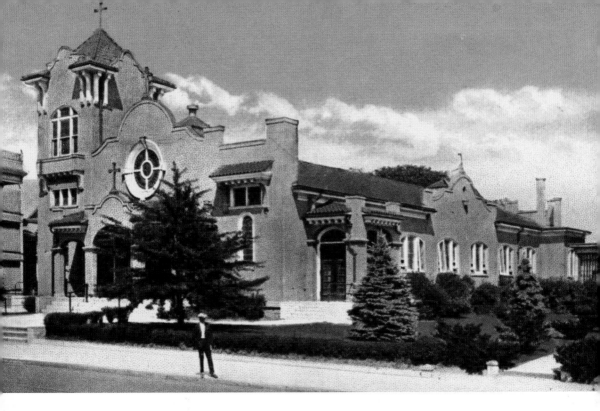

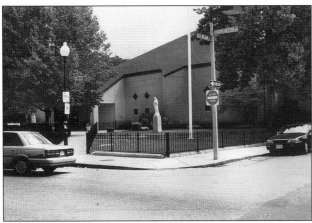

St. William's Roman Catholic Church was founded in 1909 on Dorchester Avenue. The original Spanish Mission–style structure, which was designed by William Sheehan, was destroyed by fire in the 1980s. A new church, decidedly modern in its architecture, was subsequently built on the site. (Courtesy of Earl Taylor.)

St. Paul's Roman Catholic Church was founded in 1907. Designed by Maginnis & Walsh, the church was built between 1923 and 1937 at Hartford and Lingard Streets. It has been said that St. Paul's is one of the most beautiful Gothic Renaissance churches in America. (Author's collection.)

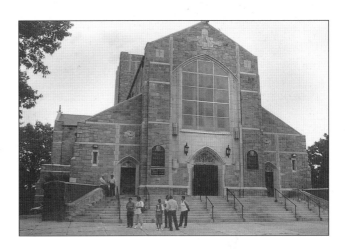

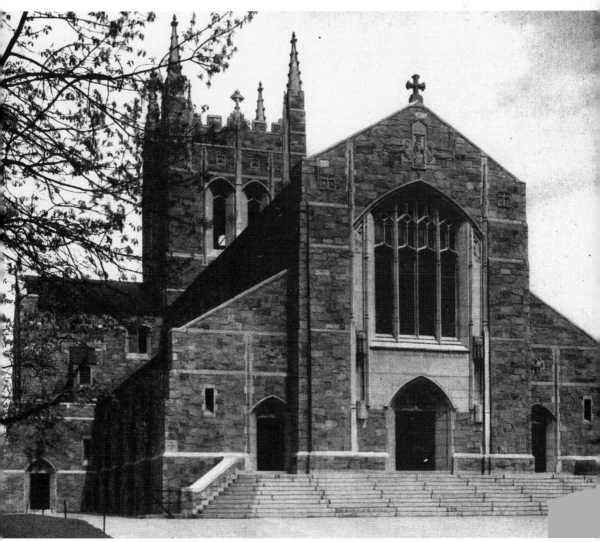

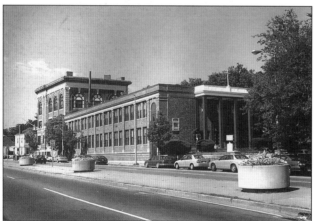

The former New England Telephone & Telegraph Building, on Columbia Road in Upham's Corner, was purchased by the Archdiocese of Boston and was remodeled in 1945 by the architectural firm of Holmes & Edwards as St. Kevin's Roman Catholic Church. The new design retained the structure's facade, but a slender-columned entrance and cornice were added to the side. On the far left is the impressive Dorchester Municipal Building, designed by Charles Besarick, at the corner of Columbia Road and Bird Street. (Author's collection.)

Grove Hall is seen in this 1932 photograph. The neighborhood was named for Boston merchant Thomas Kilby Jones's estate, which once stood on the site currently occupied by Ma Dixon's Restaurant, at the junction of Washington Street and the Brush Hill Turnpike (now Blue Hill Avenue). Laid out in 1805, Blue Hill Avenue divides Roxbury (on the left) and Dorchester (on the right). By the early 20th century, the construction of large apartment buildings and an impressive commercial block at the corner of Warren Street made this area an urban center. (Courtesy of Frank Cheney.)

Chapter 4
TRANSPORTATION

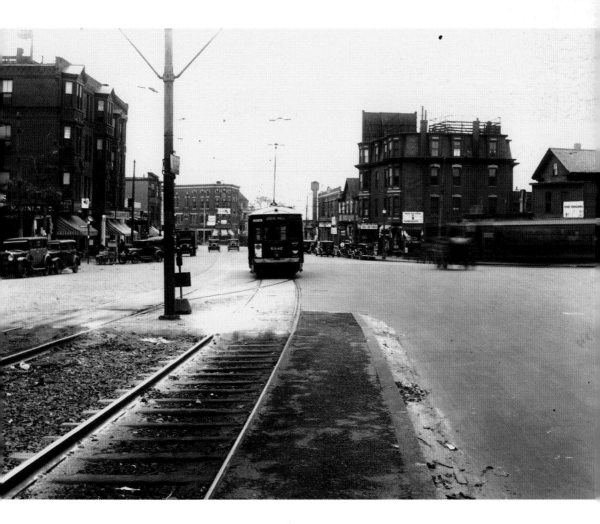

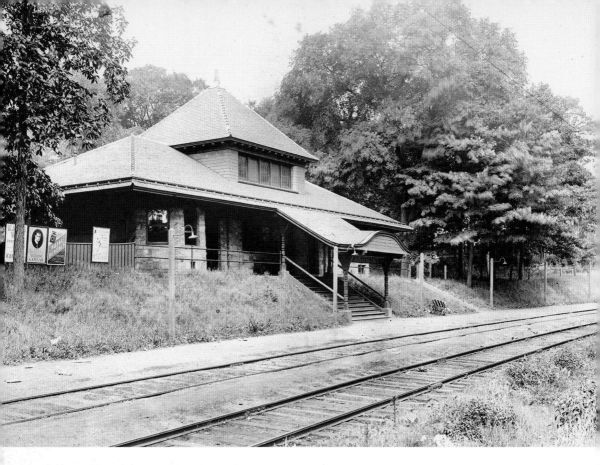

Ashmont Station, on the Dorchester and Milton Branch of the Old Colony Railroad, is shown in 1923. The one-story shingled-roof station featured a waiting room and ticket office. Portions of the building have been incorporated into a more modern station that serves as the southern terminus of the Red Line of the Massachusetts Bay Transit Authority (MBTA). The station is also a connector for numerous bus lines and the surface trolley to Milton and Mattapan. (Courtesy of Frank Cheney.)

Savin Hill Station, on the Red Line of the MBTA, was accessed via Savin Hill Avenue. Seen in 1925, the station had once been a stop on the Old Colony Railroad and served a densely built-up neighborhood. In 2004 the station was removed, to be replaced with a more modern structure. The site has been cleared and awaits the new construction. (Courtesy of Frank Cheney.)

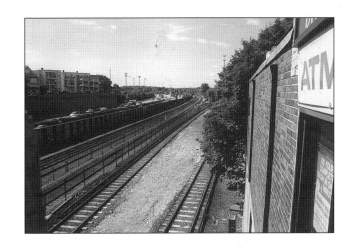

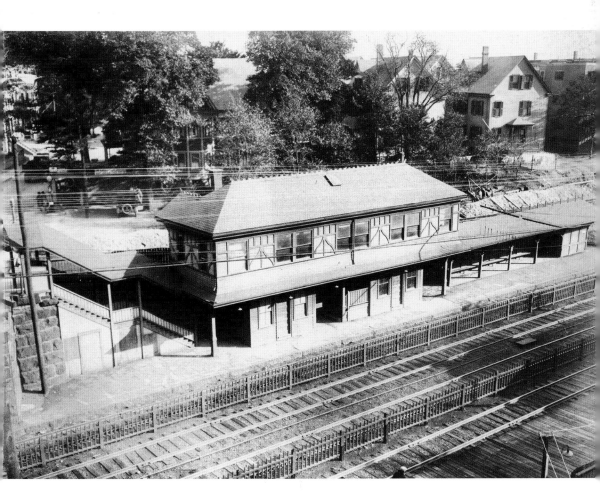

Seen in a photograph taken *c.* 1930 from Savin Hill, the tracks of the MBTA's Red Line pass the three-deckers built in the 1920s on the flat of Savin Hill. This area of Dorchester saw rapid development at the dawn of the 20th century, with the streetcar operating along Dorchester Avenue and the Old Colony Railroad (the predecessor to the MBTA). After Dorchester's annexation to Boston on January 4, 1870, ease of transportation allowed middle-class families to move to the streetcar suburbs. A building boom ensued and went unabated for the next five decades. After World War I, huge tracts of land in Dorchester were developed for multiple-family dwellings, including the three-decker, Dorchester's unique contribution to American architecture. (Author's collection.)

This passenger station on the Old Colony Railroad stood on Crescent Avenue. Seen in 1875, the small clapboard-and-shingle station was distinguished by an iron-crested asymmetrical tower. Today, the modern JFK/UMass Station, on the Red Line, replaces the original station, which was known for six decades as Columbia Station (named for Columbia Road). (Author's collection.)

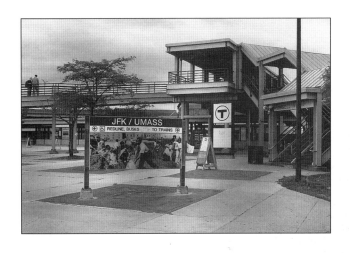

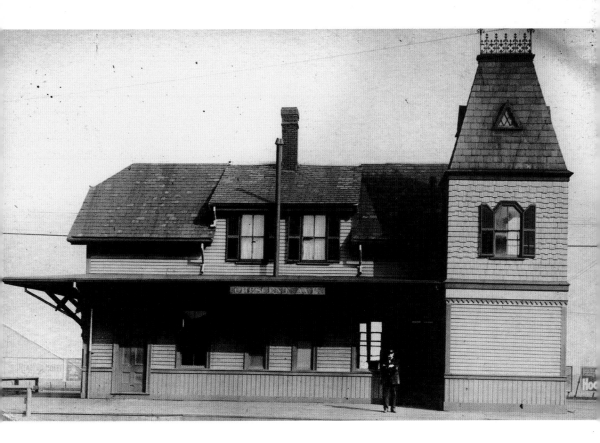

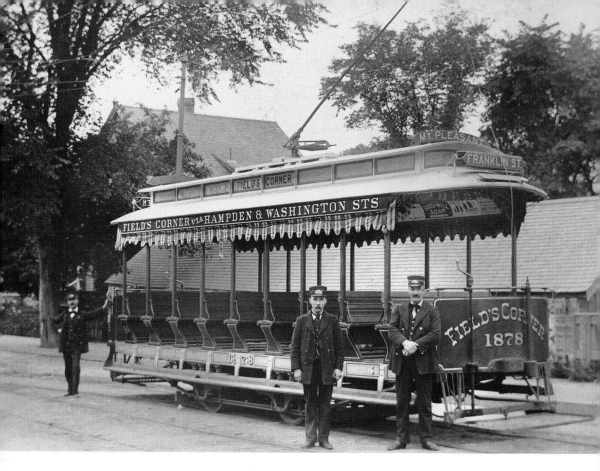

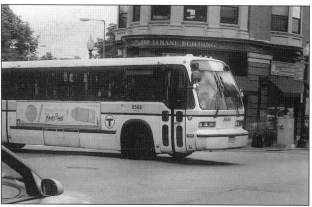

This streetcar, No. 1878, originated on Franklin Street in downtown Boston. It provided passenger service to Field's Corner via Washington Street, Hampden Street (Mount Pleasant in Roxbury), Dudley Street, Hancock Street, and Dorchester Avenue. Today, buses operate on the main streets of Dorchester. Bus No. 8588 is seen in front of the Lenane Building, at Adams Street and Dorchester Avenue, in Field's Corner. (Courtesy of Earl Taylor.)

M ilton Station, on the Boston Elevated Railway, was built in 1898 as a large streetcar shed on Dorchester Avenue in Dorchester Lower Mills. Here streetcars would return until they resumed service in the morning. In this view, a crosstown streetcar emerges from the station. A waiting room can be seen to the right of Morrill's Dining Room. Located on the site today is the red-brick high-rise Lower Mills apartment complex for seniors. (Courtesy of Frank Cheney.)

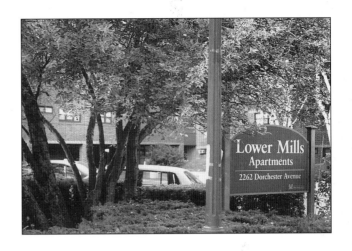

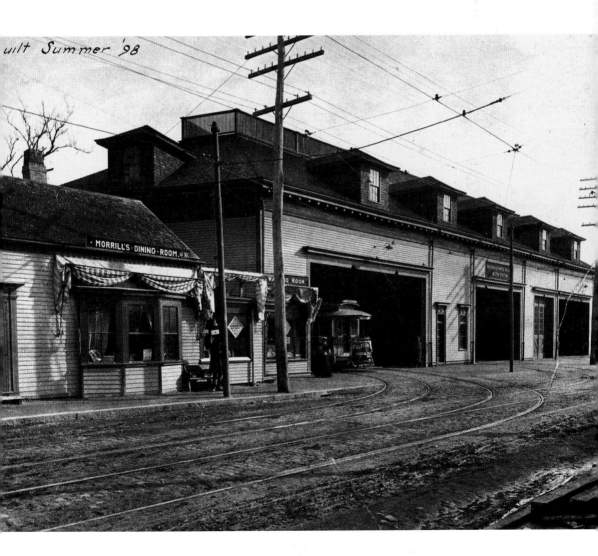

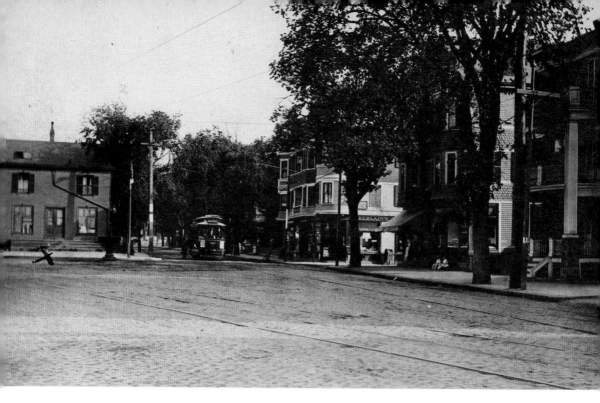

King Square is the junction of Neponset Avenue, Adams Street, and Parkman Street. It was named for Edward and Franklin King, brothers who were 19th-century residents and land developers in Dorchester. A streetcar approaches the square from Adams Street, which by 1910 was built up with three-deckers and buildings with first-floor storefronts. A water trough for horses can be seen in front of the house on the left, along with Dash, a well-known neighborhood dog. Today, the former site of that house is occupied by a retail establishment. (Author's collection.)

Blue Hill Avenue, seen in a view looking north toward Grove Hall, was once known as the Brush Hill Turnpike, a toll road connecting Dorchester, Roxbury, and Milton. A streetcar (No. 2331) travels toward Mattapan Square. On the left, at the corner of Seaver Street, is the Scollay Apartments building, designed by Fred and C. A. Russell. This large structure was the precursor to the many apartment buildings erected along Blue Hill Avenue and Seaver Street between 1910 and 1940. In the center can be seen St. John–St. Hugh's Roman Catholic Church. (Courtesy of Earl Taylor.)

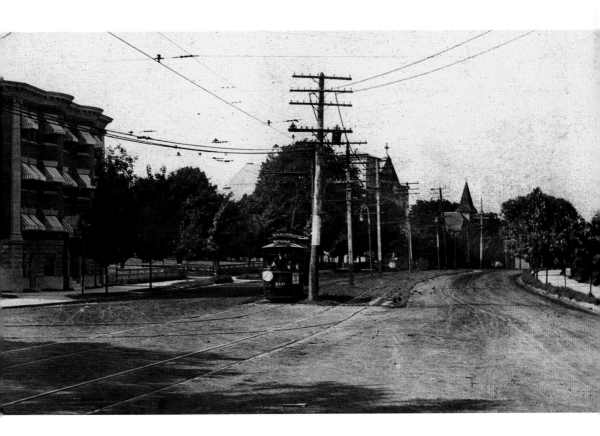

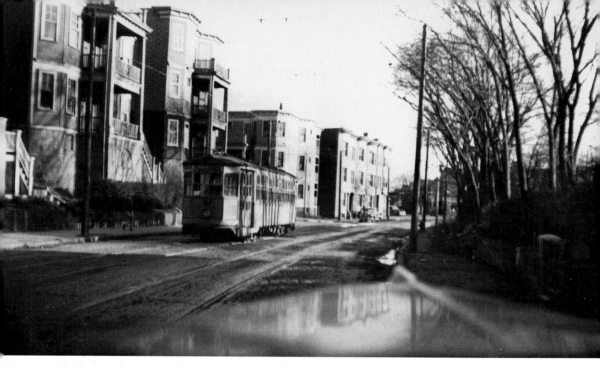

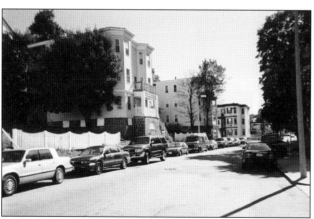

No. 5868 (a Type 5 streetcar) is seen in 1949 on Geneva Avenue at Everton Street. This area of Geneva Avenue near Bowdoin Street was referred to as "Cracker Hollow." In the early 20th century, the land was subdivided, and numerous three-deckers were built there for the working middle class. The buildings on the left are Geneva Avenue Nos. 272, 276 (now demolished), and 280, at Everton Street. (Courtesy of Earl Taylor.)

Streetcar No. 5603 is seen in 1936 at the corner of Columbia Road and Washington Street. The turreted mansion is the Ivers W. Adams House, built *c.* 1870 between Wilder Street and Columbia Road. At the rear is a carriage house with a cupola. Today, the site is occupied by a Burger King and the offices of United Housing Management and the Department of Transitional Assistance. On the far left is the Grove Hall Universalist Church, designed by Francis R. Allen and built in 1894. It is now the Holy Tabernacle Church. (Courtesy of Earl Taylor.)

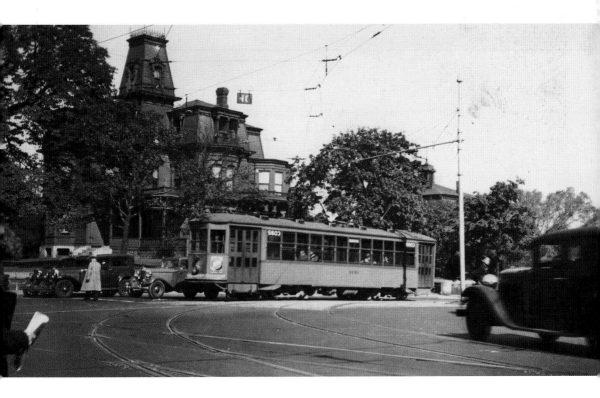

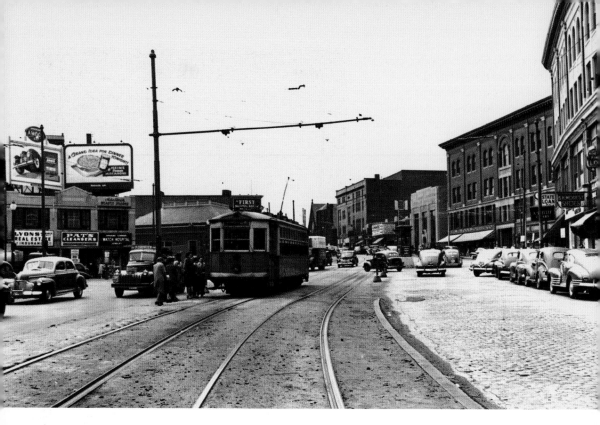

In this 1948 view of Upham's Corner, streetcar No. 5560 has stopped on Columbia Road near Stoughton Street to allow passengers to board for Andrew Square, a stop on the Red Line of the MBTA. Seen on the right are, from front to back, the S. B. Pierce Building, the Columbia Square Building (flanking Dudley Street), and the art deco facade of the Dorchester Savings Bank. On the left are a 1930s commercial block and the Shawmut National Bank, both built on the former site of the Dorchester, a large apartment building. (Courtesy of Earl Taylor.)

Streetcar No. 5622, headed toward Ashmont Station, turns from Bowdoin Street onto Washington Street at Four Corners in 1948. A horse-drawn wagon can be seen on the left at Bowdoin Avenue. The one-story red-brick and concrete commercial block was built in the 1930s to house small shops and restaurants for the neighborhood residents. (Author's collection.)

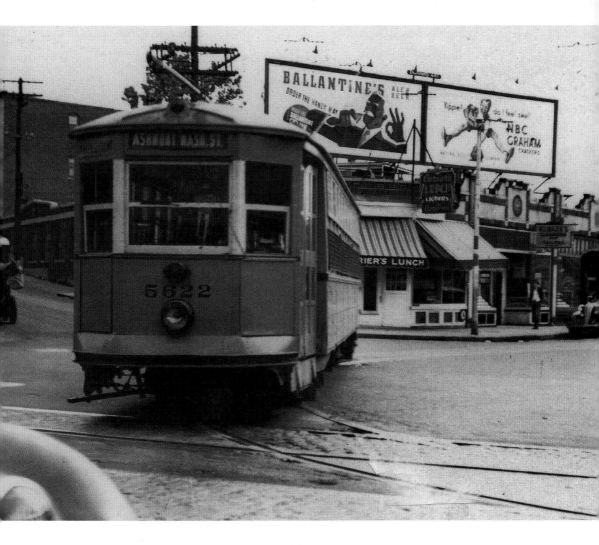

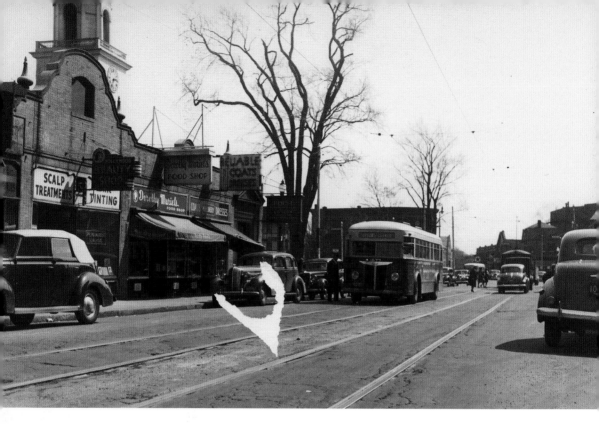

Bus No. 1677 is seen in 1942 at the corner of Washington and Moultrie Streets in Codman Square. This bus operated on a route from Ashmont Station to Upham's Corner, via Talbot Avenue and Washington, Bowdoin, and Hancock Streets. The Dutch-gabled commercial block on the left was built in the 1930s. A portion of the spire of the Second Church in Dorchester can be seen rising above the storefronts. (Courtesy of Frank Cheney.)

This view looks east toward Pierce Square (named in 1895 for Boston mayor Henry Lillie Pierce) from the corner of River Street. The stores along Washington Street are, from right to left, Miss Cook's Creamery & Bakery, Badlam's Cabinetmaking Shop (later Talbot's), the large John C. Talbot grocery store, and Clay's Meat Market. Today, a Lil Peach store, Spukies 'n Pizza, and a parking lot occupy this site. (Author's collection.)

Chapter 5

DORCHESTER
STREETSCAPES

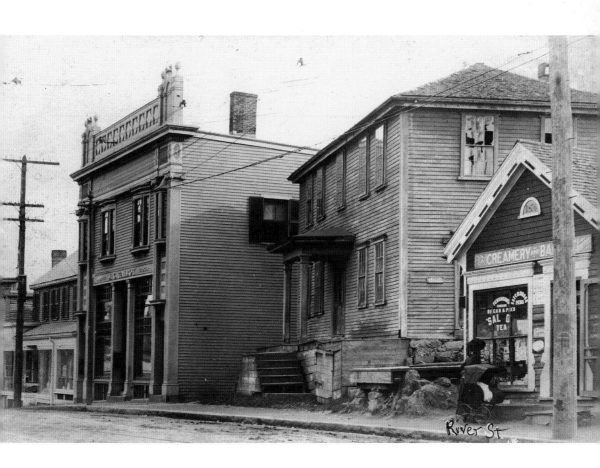

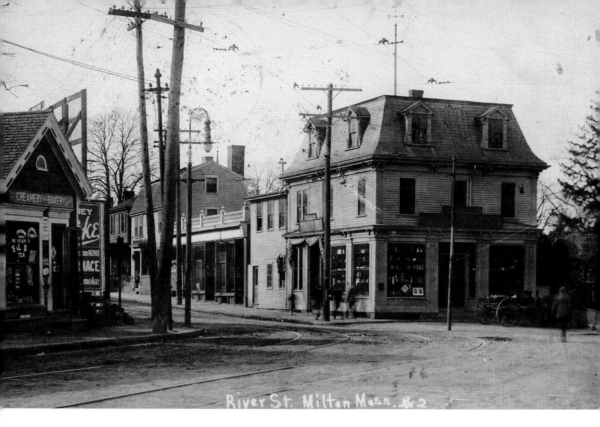

River St. Milton Mass. #2

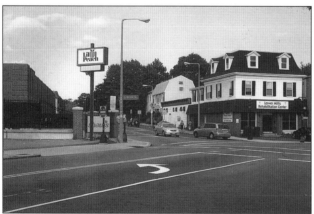

The junction of Washington and River Streets had Miss Cook's Creamery & Bakery, on the left, and the Tolman store, on the right. The two houses on River Street, seen in the center, still stand. In the present-day photograph, the Lil Peach convenience store can be seen on the left, along with a portion of Shaw's. The Lower Mills Rehabilitation Center is on the right. (Author's collection.)

In this view looking north along Dorchester Avenue, the panoply of 19th-century architecture can be seen—from the severely plain Victorian duplex (on the left) to the turreted three-decker (built in 1893 by F. H. McDonald). Pictured from left to right are Tiffany Terrace Nos. 2183–2181, 2175, 2173, and 2171, and No. 2159 Dorchester Avenue. This Lower Mills residential streetscape shows how diverse the housing stock was in Dorchester by the beginning of the 20th century, when the population boomed. On the right today is Caritas Carney Hospital. (Author's collection.)

Dor. Ave. from Bellows Place North

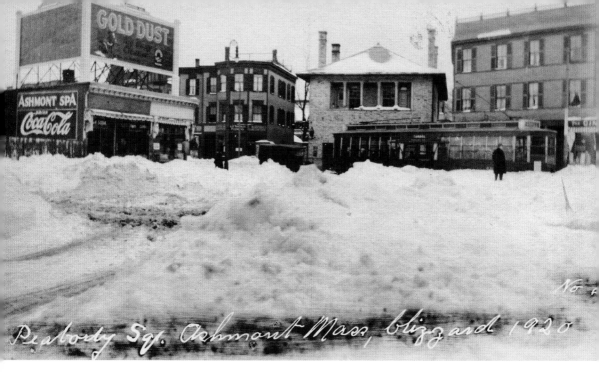

Peabody Sq. Ashmont Mass, blizzard 1920

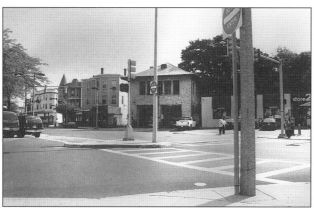

Peabody Square, seen in 1920, had the Ashmont Firehouse (center), designed by city architect Edmund March Wheelwright. Named for Oliver White Peabody (1834–1896)—a cofounder of the Kidder, Peabody & Company investment house—the square is a major intersection near Ashmont Station. On either side are three-deckers with first-floor storefronts. The streetcar in the foreground operated along Dorchester Avenue from Pierce Square to Andrew Square in South Boston. (Courtesy of Earl Taylor.)

Four Corners—the intersection of Washington, Harvard, and Bowdoin Streets—has been known as such since the early 19th century. The Chittenden Block, in the center, was built by two brothers who kept a grocery store on the first floor. This three-story rounded-bay commercial block still dominates the area. The houses seen on the left—the Moffet House (left) and William Schmehl's house and shop—were eventually demolished and replaced by one-story commercial blocks of stores in the early 20th century. (Author's collection.)

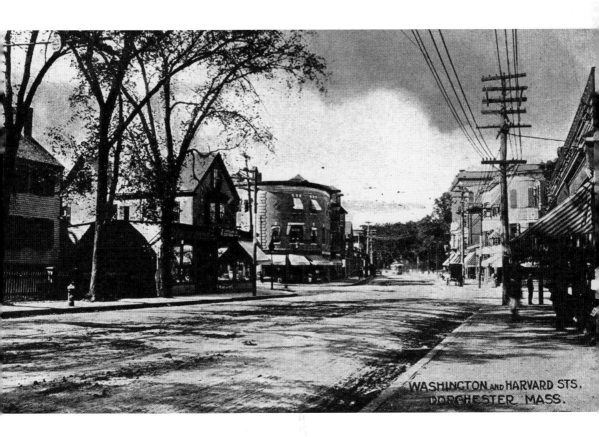

WASHINGTON and HARVARD STS.
DORCHESTER MASS.

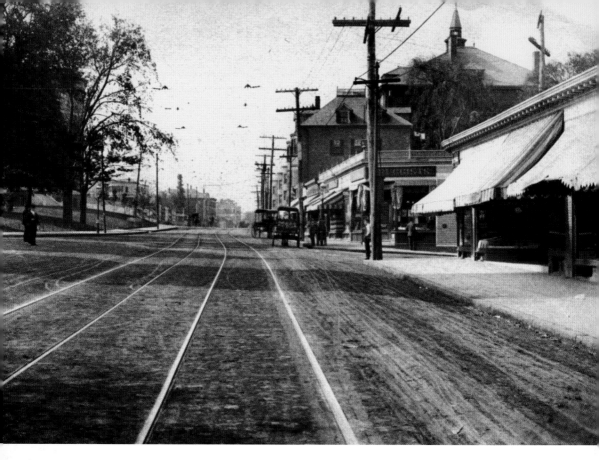

Bowdoin Street, seen in a view looking west from Easton Square, was a small business area. In this view, storefronts (flanking Quincy Street on the right) stand near St. Peter's Roman Catholic Church. A corner of Mount Ida (the Harris-Capen estate) can be seen on the left. The roof of St. Peter's School can be seen rising high above the stores on the right. This streetscape remains virtually unchanged a century later. (Courtesy of Frank Cheney.)

The Farrington store, which stood at the corner of Dorchester Avenue and East Street, was a popular grocery store that used a horse-drawn wagon to deliver dry goods locally. The intersection is known as Glover's Corner for the original proprietor of the store, but it was once known as "Sodom and Gomorrah" because of its proximity to the town landing and the bars frequented by sailors. Today, the International Computer Solution is located in the former store. (Author's collection.)

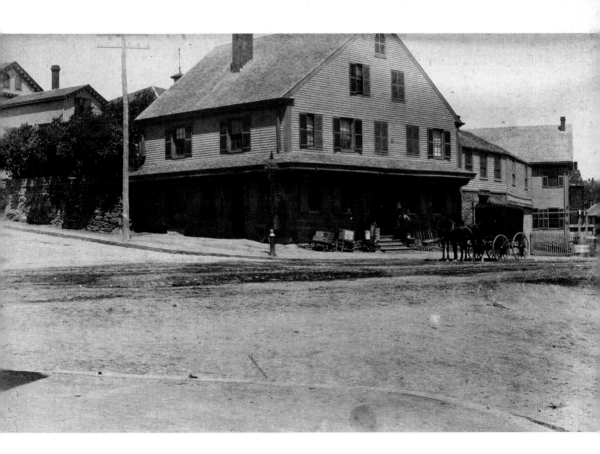

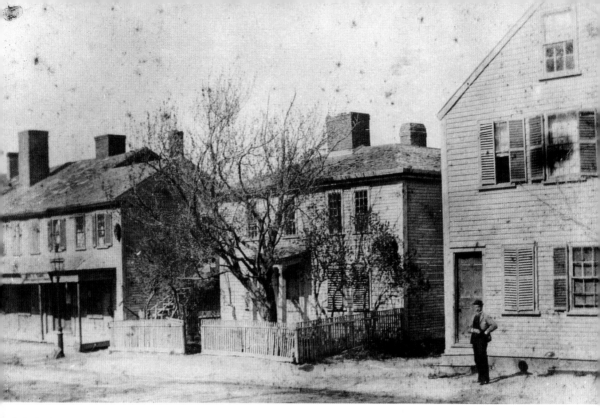

Roswell Gleason (1799–1887) opened his britannia-ware manufactory, pictured *c.* 1870, on the Upper Road (now known as Washington Street), just south of Four Corners. Britannia-ware was produced in the factory until the mid-1860s, when Gleason and his sons, Edward and Roswell Jr., began silver-plating base metal to produce what is thought to be amongst the first silver-plate metal made in this country. After a fire in 1872, the factory closed, and by the turn of the 20th century, the site had become a park known as Mother's Rest. Today, the area is undergoing extensive renovations, and is called Corbett Park. (Author's collection.)

The junction of Dorchester and Savin Hill Avenues had been built up with commercial blocks on either side by the early 20th century. On the left is the Savin Hill Pharmacy, and on the right is Tessier's Pharmacy. The three-deckers in the center, on Savin Hill Avenue, were precursors to the massive building of three-deckers in Dorchester between 1900 and 1930. Today, Brooks Pharmacy occupies the site to the left, and a garage has replaced Tessier's. (Courtesy of Earl Taylor.)

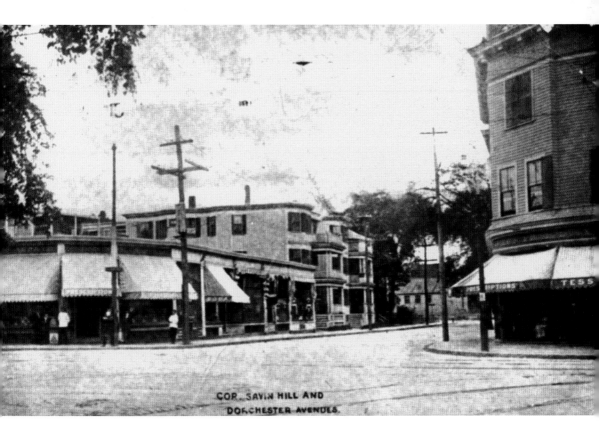

COR. SAVIN HILL AND
DORCHESTER AVENUES.

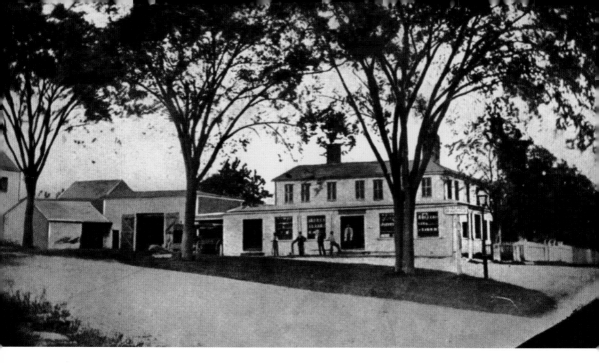

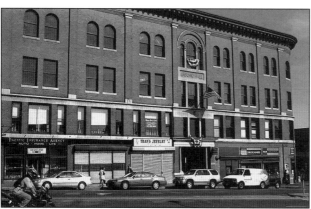

Upham's Corner is the junction of Columbia Road and Dudley and Stoughton Streets. Amos Upham (1788–1879) opened a general store at the corner of Boston Street (later Columbia Road) and Dudley Street. Seen in 1861, the store became a Dorchester institution and was operated by three generations of the Upham family. Today, the Columbia Square Building (the former Masonic hall) stands on the site and has storefronts on the first floor. (Author's collection.)

Upham's Corner is pictured in a view looking west on Columbia Road in 1905. By that time, the area had become an urban crossroads. The buildings in this view include, on the right side of the street (from front to back), the S. B. Pierce Building, the Columbia Square Building, and Winthrop Hall (with gabled roof). Standing on the left side of the street is the Dorchester apartment house. (Author's collection.)

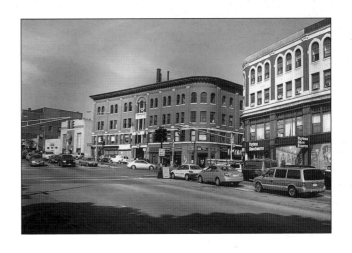

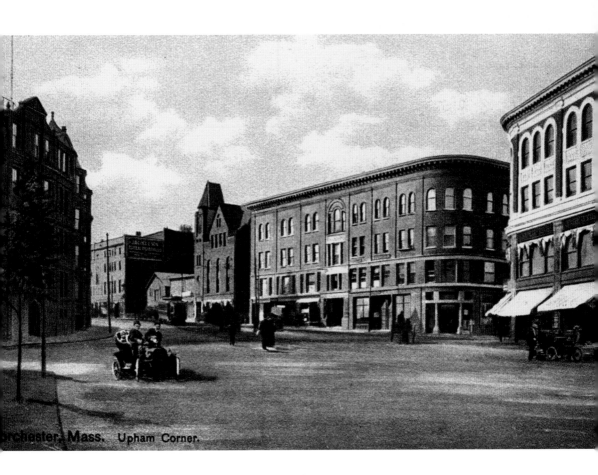

Dorchester, Mass. Upham Corner.

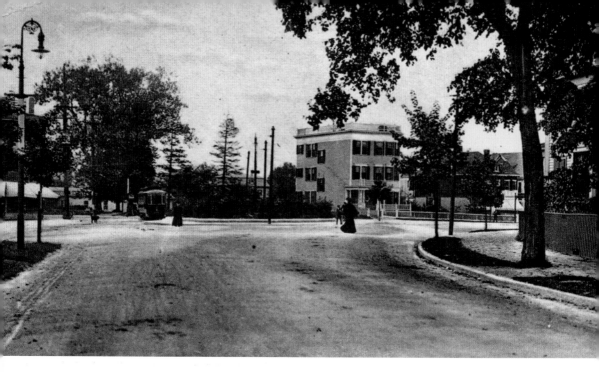

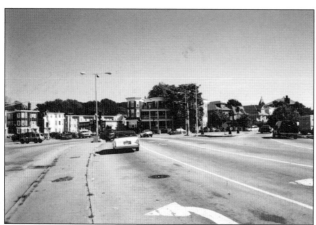

Five Corners, or Edward Everett Square, is the junction of Columbia Road, Massachusetts Avenue, and Boston and West Cottage Streets. In this 1906 photograph, a streetcar emerges from Boston Street. The three-decker in the center (718 Columbia Road) was built on the site of the birthplace of Edward Everett, the noted orator and president of Harvard College. Dunkin' Donuts, a large three-decker, and Kentucky Fried Chicken stand at the intersection today. (Courtesy of Earl Taylor.)

The Stewart Building was a large turreted complex at the corner of Geneva Avenue and Tonawonda Street. Constructed by the well-respected John Irving Stewart (1847–1927), the building housed Stewart's real-estate office, as well as stores on the first floor and offices above. Stewart built 54 houses in Dorchester Centre and 61 houses and 3 commercial blocks in Ashmont. It was once said that "[Stewart's] achievements furnish a striking example of what prudence and untiring energy can accomplish." The impressive block was later demolished and is today a storage yard for construction. (Courtesy of Earl Taylor.)

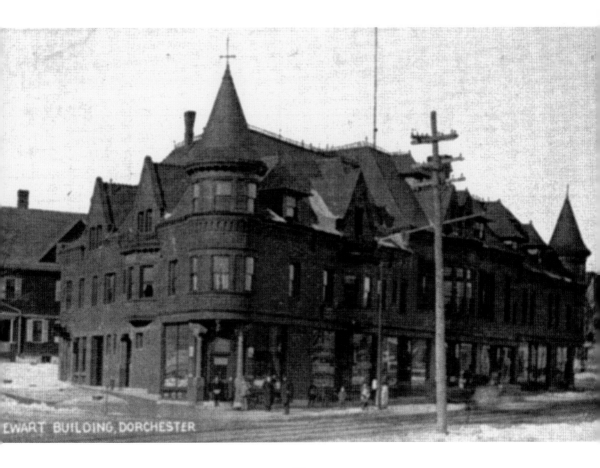

EWART BUILDING, DORCHESTER

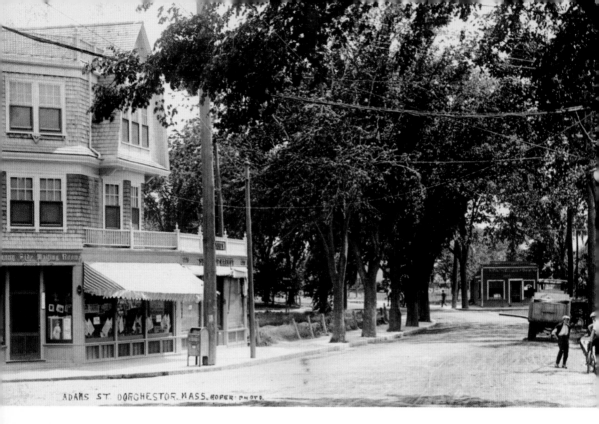

ADAMS ST. DORCHESTER. MASS. ROPER PHOTO.

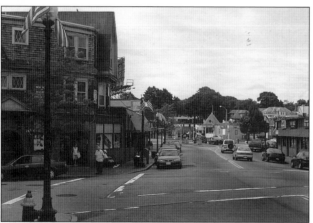

Adams Village—or Sunny Side, as it was often called—was the junction of Adams and Minot Streets. Charles Adams opened a general store in a large Shingle-style building (left), which also served as the Sunny Side Waiting Room for the streetcars that operated from the village to Field's Corner. In the distance is Marsh Street (now Gallivan Boulevard). Today, Gerard's Restaurant, operated by Gerard Adoumenes, is in the Sunny Side Waiting Room. Adams Village is a thriving shopping area. (Courtesy of Earl Taylor.)

The Williams Motor Company sold "good used cars" on a lot located at 780 Gallivan Boulevard, near what is today Neponset Circle. Fred L. Williams, seen on the right beside a car, bought and sold used cars in Dorchester between 1930 and 1950. Today, this property is owned by Sovereign Bank New England, which is building a new bank on the site. (Courtesy of Earl Taylor.)

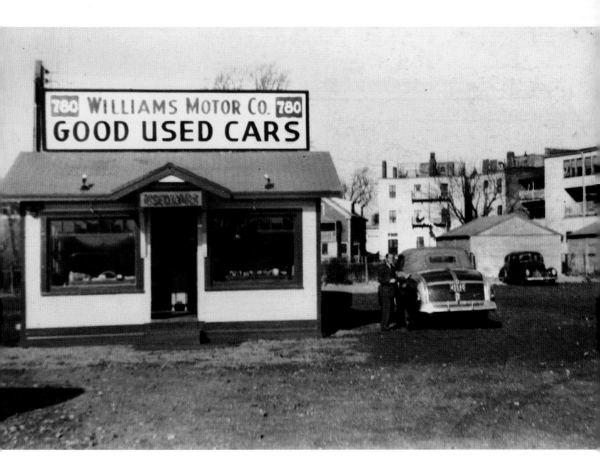

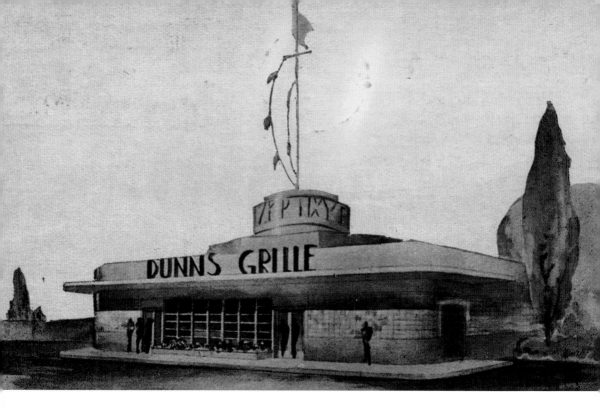

Dunn's Grille, seen in 1941, was at 770 Gallivan Boulevard, near Neponset Circle. The restaurant prided itself on its home-cooked food, pastries, and its own ice cream—all of which were served, as one advertisement said, "in the pleasant atmosphere of our dining-room by our charming waitresses!" The distinctive restaurant, one of a chain owned by B. R. Dunn, was later to become the site of a Bickford's Restaurant. (Courtesy of Earl Taylor.)

The Wales House, seen in 1909, was a huge Colonial Revival mansion at 186 Columbia Road, between Oldfields and Stanwood Streets. S. Walter Wales was in the hack, livery, and stable business in Grove Hall, and was the proprietor of the Boulevard Stables on Blue Hill Avenue. His estate also included a barn (far right), where his racehorses Rondo, Clara, Chrome, and Kitty were stabled. The horses were raced in the Dorchester Gentlemen's Driving Club races at Franklin Field. (Courtesy of Earl Taylor.)

Chapter 6

DORCHESTER HOUSES

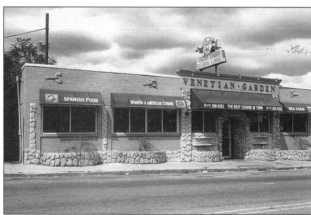

The Blake House, seen in 1890, was built by Elder James Blake in 1650 near Five Corners, on what is today Massachusetts Avenue. Enlarged over the centuries, the house was moved in 1895 by the Blake family and the Dorchester Historical Society to Richardson Park on Columbia Road, where it was restored by architect Joseph Hodgdon to its presumed 1650 appearance. Today, the former site of the house is occupied by the Venetian Garden restaurant (said to serve "the best cuisine in town") and a portion of the parking lot for the Boston Edison Company. (Author's collection.)

The Tuttle House, seen in 1889, was built by Joseph Wiswall *c.* 1660 on Savin Hill Avenue, between Tuttle and Sydney Streets. In 1822, Joseph Tuttle, who had recently moved to Dorchester, enlarged the house with two wings and opened the Tuttle House, a fashionable seaside hotel that was patronized by Bostonians for two generations. It was Tuttle who renamed Rock Hill (later known as Old Hill) as Savin Hill for the columnar red junipers that grew in great profusion on the hill. Today, this is the site of St. William's School. (Author's collection.)

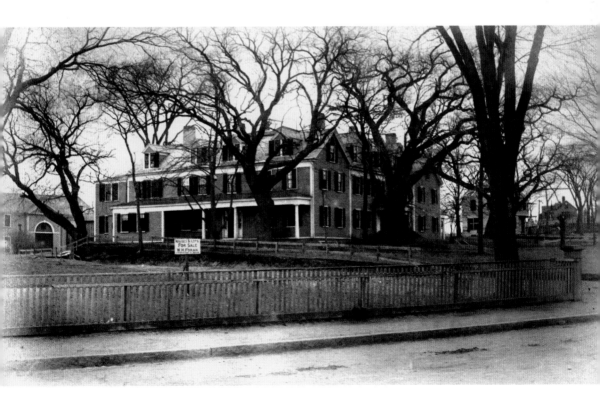

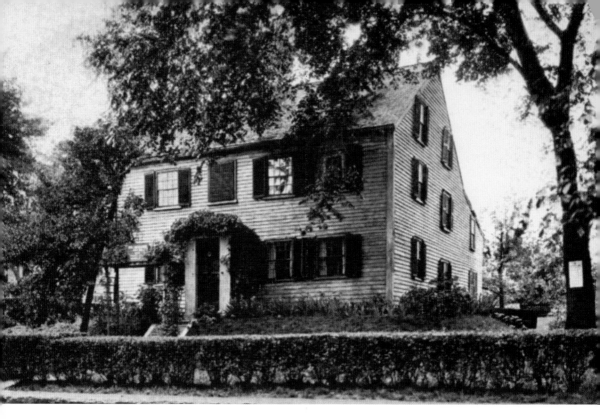

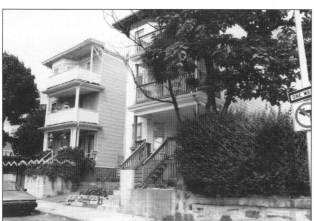

The Bird-Sawyer House, once located at 41 Humphreys Street, near Upham's Corner, was built in the 17th century by the Bird family. During the Siege of Boston and the Fortification of Dorchester Heights in 1776, the house was used as the headquarters of the American troops headed by Gen. George Washington (who was said to have lost a pistol there). The house was demolished in the 1930s, and three-deckers were built on its site. (Author's collection.)

The Thomas Pierce House stood on Adams Street, near the corner of Minot Street. A small one-story Cape, it was demolished to make way for a movie theater in the 1940s. The site is now a Shell station in Adams Village. (Author's collection.)

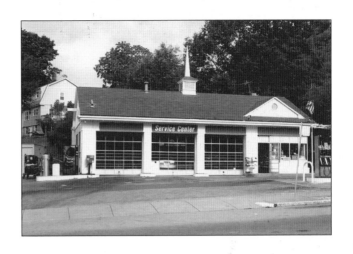

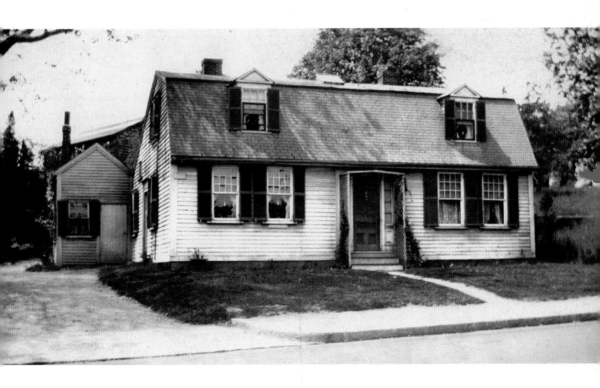

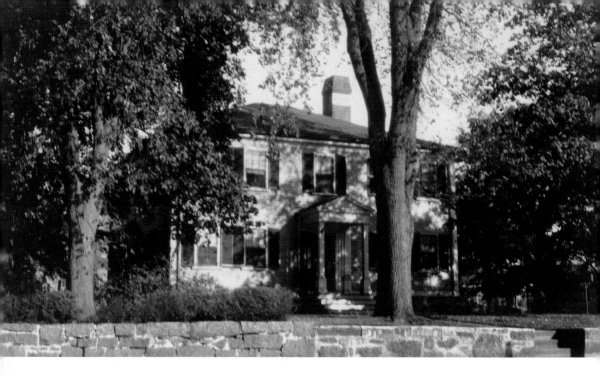

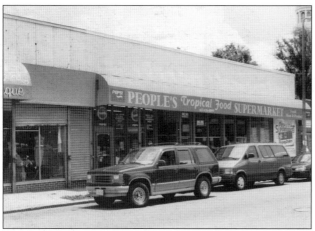

The Joseph Clap House was built in 1798 on Washington Street (then known as the Upper Road) between Kenwood and Moultrie Streets. A charming five-bay Colonial erected by builder Oliver Warren, the residence was set back from the street with a stone wall, and the grounds were shaded by mature trees. After the death of Henry Clap Kendall (the last descendant to live there), the house was demolished to make way for a commercial block. A First National store was later built on the site, which is now occupied by the People's Tropical Food Supermarket. (Author's collection.)

The Oliver-Everett-Richardson House was built in 1746 at Five Corners (the junction of Columbia Road, Massachusetts Avenue, and Boston and West Cottage Streets). This house, seen in 1890, was the birthplace of Edward Everett (1794–1865), who was a president of Harvard University, an ambassador to the Court of Saint James, and a noted speaker who delivered his "Gettysburg Oration" at the dedication of the national cemetery in 1863. Today, the former site of the house is occupied by a Dunkin' Donuts and two three-deckers that were built on Columbia Road in the early 20th century. (Author's collection.)

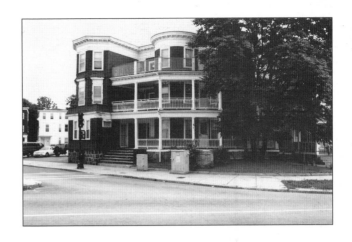

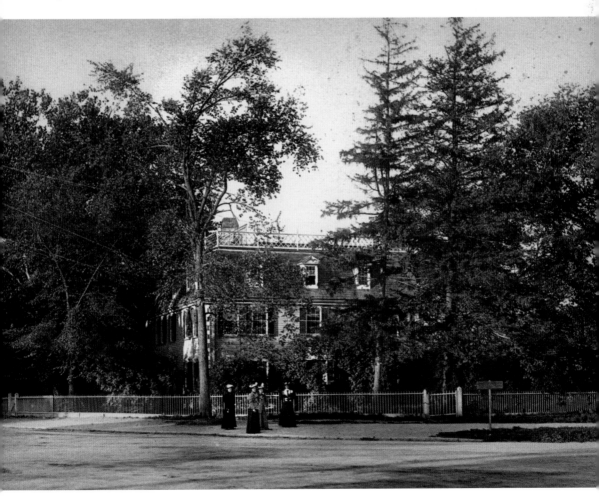

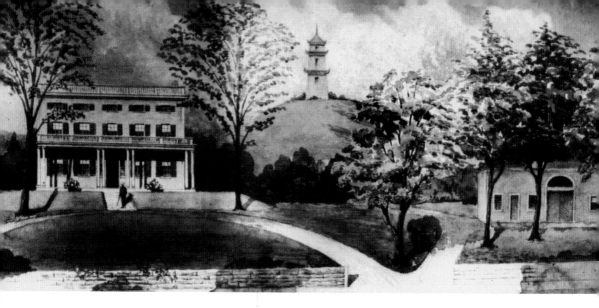

The Macondray-King House, built c. 1810, was an elegant three-story Federal house that stood on Adams Street (then known as the Lower Road), opposite Lonsdale and Mallet Streets. The estate included a three-story summer house (built to resemble a pagoda), which surmounted Ginger Hill, the western slope of present-day Pope's Hill. Capt. Frederick Macondray, a supercargo with Russell and Company, was in the China trade, so the pagoda was an appropriate design choice. The house was later owned by the King family, for whom King Square was named. Today, the site is a park and baseball field. (Author's collection.)

The Swan House was built at 29 High Street on Meeting House Hill. The charming Greek Revival house has four fluted Doric columns that create a porch in front. After the death of Catherine E. Shepard, granddaughter of the original owner, the residence became "the manse" of the First Parish in Dorchester (where ministers and their families lived). Today, the house is still owned by the First Parish Church and is almost unchanged. (Author's collection.)

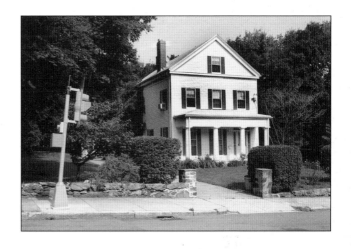

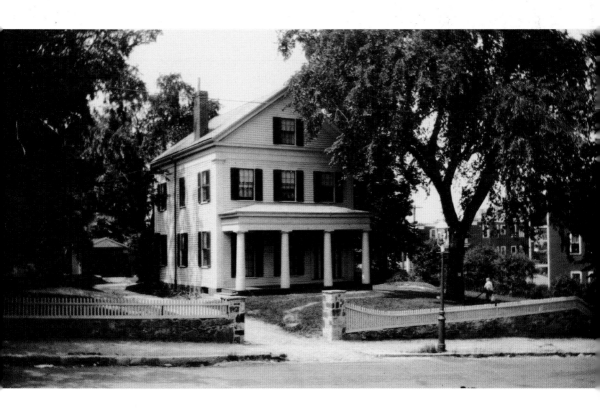

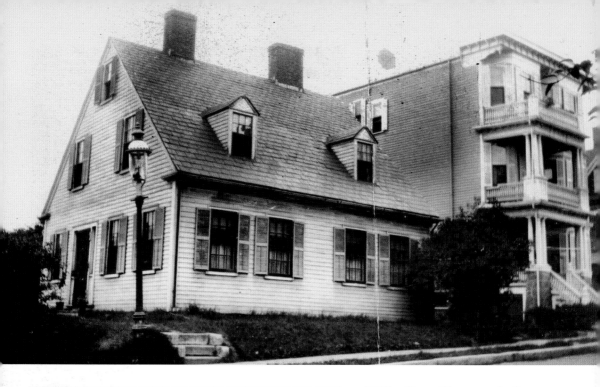

The Howe House was built *c.* 1840 at 16 Howe Street, near Kane Square. A small one-story Cape Cod–style home, it once stood in open land. By the early 20th century, a three-decker was built almost adjacent to the house. Today, the Howe House is a private residence. (Author's collection.)

The Adams House was an Italianate house designed by Dorchester architect Luther Briggs Jr. and built on Dorchester Avenue near Faulkner Street. William Taylor Adams, whose pen name was Oliver Optic, was a noted 19th-century author of boys stories. The house, which sat adjacent to the Dorchester and Milton Branch of the Old Colony Railroad, was later demolished to make way for the Field's Corner Station on the Red Line of the MBTA. Today, a temporary entry kiosk is on the site, and the station has been remodeled. (Courtesy of Earl Taylor.)

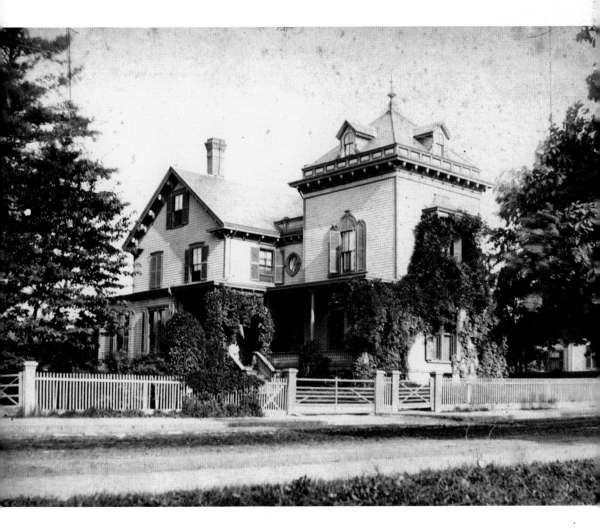

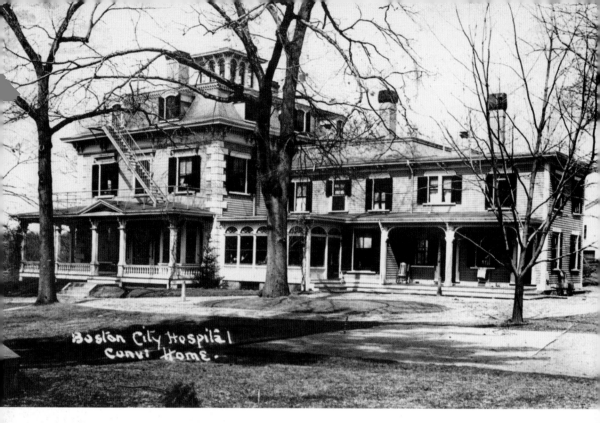

Boston City Hospital
Conv. Home.

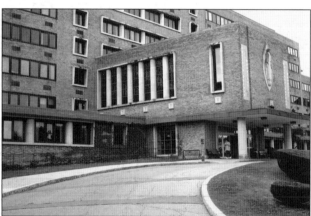

The Italianate-style Asaph Churchill House was designed by Dorchester architect Luther Briggs Jr. and was built at 2150 Dorchester Avenue, next to Badlam's Woods (which later became the Olmsted-designed Dorchester Park). Asaph Churchill (1814–1892) was a prominent attorney whose 15-acre estate was sold in 1891 to the Boston City Hospital's Convalescent Home. In 1951, the property became the site of Carney Hospital, founded in 1863 through the generosity of Andrew Carney (1794–1864) and designed by Kennedy, Kennedy, Keefe & Carney. The hospital has been greatly enlarged over the years and today is a member of the Caritas Christi Health Care organization. (Author's collection.)

The Clapp-Dyer House was built in 1810 by James Clapp as a five-bay Federal house at the corner of Boston Street (now Columbia Road) and Hancock Street. In 1867 it was purchased by Micah Dyer (1929–1917), who had moved to Dorchester from Boston's South End. Dyer vastly remodeled and enlarged the house in the Italianate style, with a piazza overlooking a wide, tree-shaded lawn. The Dyer family sold the property in 1917, and the house was demolished to make way for the Strand Theater (designed by Funk & Wilcox), which opened on Armistice Day 1918. (Courtesy of the Dyer family.)

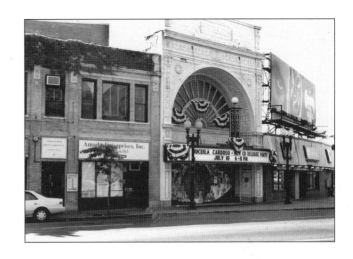

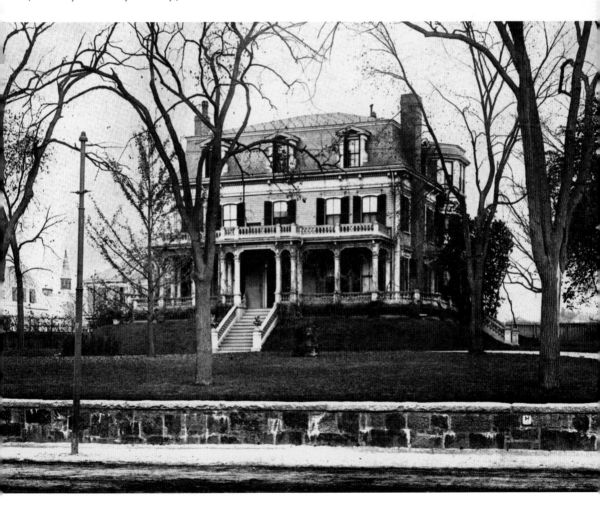

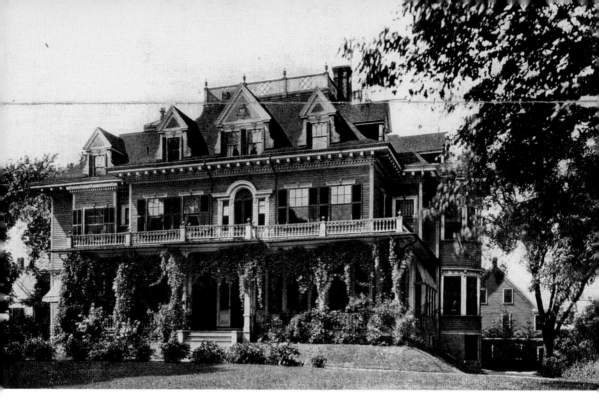

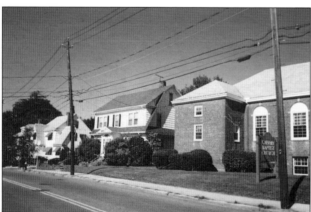

The Young House was designed by Dorchester architect Edwin J. Lewis Jr. (1859–1937) and was built at 294 Ashmont Street, on the crest of Ashmont Hill. Frank L. Young (1852–1937) was proprietor of the Young Oil Company in Boston, said to have been the largest oil-manufacturing concern in the United States at one time. The house was a pastiche of Colonial Revival details, including a Palladian window, pedimented dormers, dentiled cornices, and yards of balustrades. It was probably the most ornate residence Lewis ever designed. The house was demolished in 1938, and small one-family houses were built on the site, which is located between Adnac Terrace and the Cavalry Baptist Church. (Courtesy of Stephen Wentworth Gifford.)

The Ripley House was built by Charles and Clara May Ripley at 173 Harvard Street, on the corner of Bicknell Street. It was here that the Dorchester Women's Club was founded in 1892. On the left is the Thomas Bicknell House, which was later used as the parish hall of St. Leo's Roman Catholic Church. The Ripley House subsequently became the Gray House, where the parish held religious education classes. Today, the Haitian Multi-Service Center and the Early Education Center occupy a modern building on the site. (Courtesy of Clara May Clapp.)

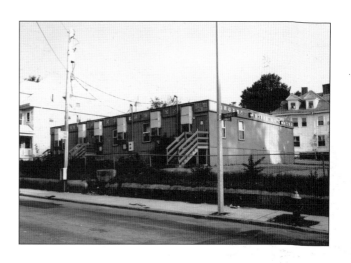

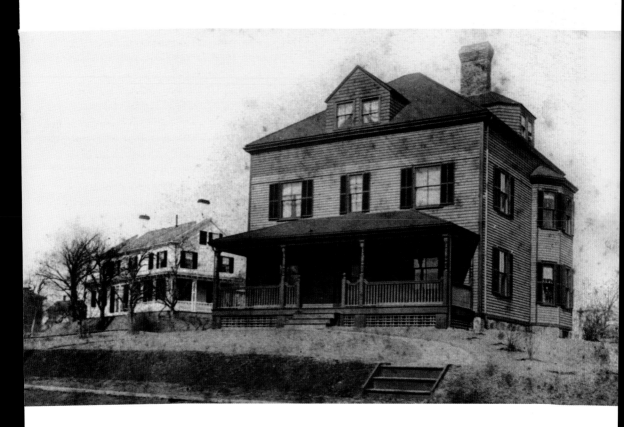

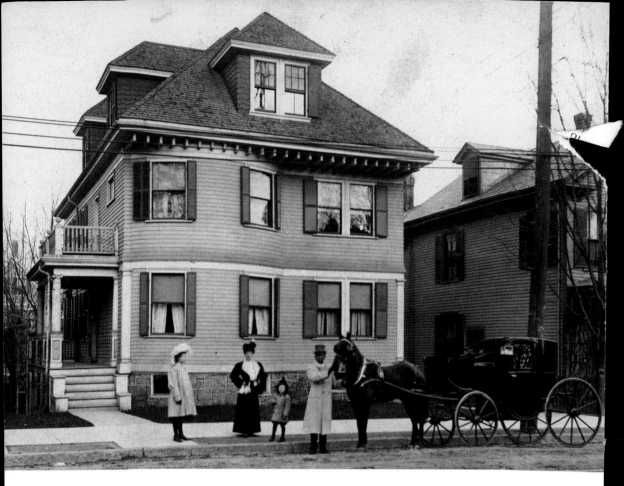

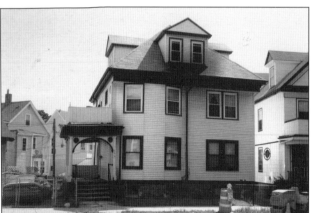

The house at 72 Pleasant Street was a comfortable Colonial Revival home with a swell-bay facade and side entrance. Standing in front of the house here are members of the Whipple family, including Margaret Whipple, Mrs. J. Percy Whipple, and Herbert Whipple. With them is the top-hatted coachman Andrew Reeve Smith, a native of Bermuda, who is holding the reins of Billy, the family horse. The house at 74 Pleasant Street, on the right, was built *c.* 1875 by Marcus Whipple. That house was demolished after Marcus's son built a two-family house on land next door *c.* 1920. (Courtesy of Earl Taylor.)